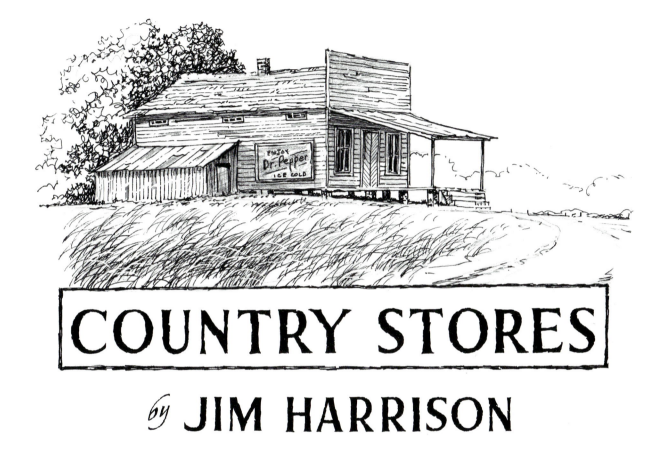

# COUNTRY STORES

### by JIM HARRISON

LONGSTREET PRESS
Atlanta, Georgia

Published by LONGSTREET PRESS, INC.,
a subsidiary of Cox Newspapers,
a division of Cox Enterprises, Inc.
2140 Newmarket Parkway
Suite 118
Marietta, Georgia 30067

Printed in the United States of America

1st printing, 1993

Library of Congress Catalog Number 92-84008

ISBN: 1-56352-067-2

This book was printed by Dickinson Press Incorporated, Grand Rapids, Michigan.
The text was set in Gilde.

Jacket design by Jill Dible.
Book design by Jim Harrison.

# Table of Contents

*This book is dedicated to all my teachers,
and especially:*

J. J. Cornforth, sign painter, who took me under his wing when I was fourteen years old. He taught me confidence, steadiness of hand, and sureness of brush stroke that has served me well for half a century.

Miss Anne Reynolds, high school English teacher, who instructed me in grammar, punctuation, and literature. More importantly, by example and words, she taught the love of beauty.

Miss Zita Mellon, art teacher, who patiently prepared and prodded me toward a fine arts career when it seemed so unrealistic for me to dream of such.

Oscar Wetherington, art teacher, who unselfishly shared his lifetime of technical knowledge at times when my progress was stalled.

John Burks, writing teacher and critic, who commands a wealth of knowledge and skills which he has masterfully used for twenty years to encourage and guide me.

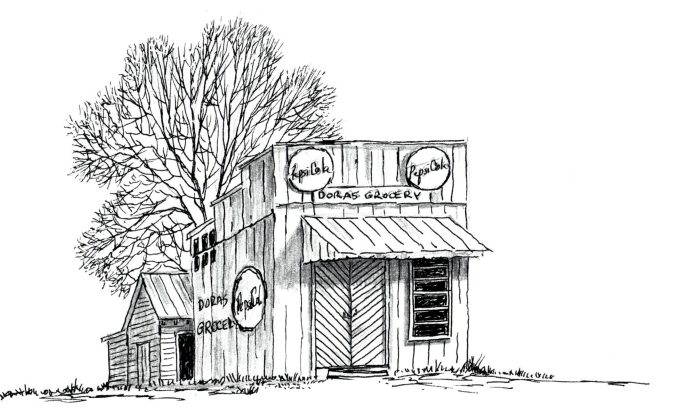

Remember them, remember them well
Gone forever, to be no more
Memories, oh memories made only there
At the crossroad country store.
— J. Wiley

# COUNTRY STORES

# Why Look Backward

I love country stores. Not only are they rich with emotional associations; they are also an essential part of our past. A search for the real, American, entrepreneurial spirit must not begin in the contemporary metropolitan offices of our giant corporations. No, not there. To learn of the development of the mercantile system in this country, one must pause, turn around, and take a backward look.

First it is necessary to travel the unpaved roads of our rural countryside, and somewhere one dirt road will eventually cross another. Though not easily recognized, at the crossing of the roads may well be remnants of a once-thriving country store. There, within unpainted pine walls can be found the beginnings of modern, enterprising America. In light and shadow the old structure's past can be felt, smelled, savored,

and learned from.

For more than half a century, I have had a love affair with old buildings, old things, and old ways. Most of my time is spent dwelling in yesteryear, and again and again I am asked why I love it so. Years ago a wiser man provided an answer: "To look only to the now is folly. To look to the past is to learn. To learn is to look to the future."

In today's America there is a disturbing school of thought propounding the idea that something new is better, more exciting, and more useful. "Throw it away and get a new one," is the constant cry of this group, who seem unwilling to take the time to glance backward and evaluate.

Not always the younger generation, these "new-getters" include government officials, church people, and educators, rich and poor alike, always hurrying to "tear it down, build a new one." This throng of closet-cleaners, throw-awayers, and tearer-downers can never offer a sound argument as to why the old is all bad and useless, but they continue to maintain their attitude of total indifference to the past.

The ways of the world have changed, and it is the selling of the fads and fashions of the day that fill the money drawers. Constant changes of style and the introduction of the new translate into more sales. We are reminded daily by the media that old things are out and new things are

"*In the early fifties, when I was fourteen years old, I worked as a sign painting apprentice to J.J. Cornforth. We painted Coca-Cola signs on the outside walls of various country stores in and around my hometown of Denmark, South Carolina. I dreamed of doing two things: I longed to put my name by Mr. Cornforth's on a Coca-Cola sign, and I wanted to paint the Welcome to Denmark signs for the city. I never got a chance to do either.*"

4

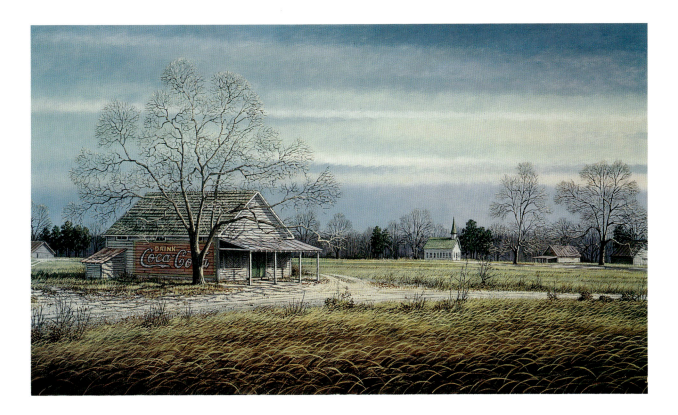

in. This kind of thinking has resulted in the reckless disregard and disposal of many of our centuries-old riches of mind and matter.

A few years ago I watched in helpless dismay and anger as my hometown allowed a wrecking crew to demolish two very sound railroad depots. The little buildings today would be the envy of any small-town landscape. Under the banner of progress, an utterly bland parking lot has been built where one of the picturesque stations stood for almost ten decades. A leaning, never-used gazebo now marks the spot where freight was once unloaded. Always moving forward but never looking backward has become the norm of modern thinking. Such an attitude vandalizes the very essence of our heritage.

When it became inevitable that the depots were to be lost, one entire ticket window, along with the potbellied stove from one of the waiting rooms, found its way into my warehouse. Additional acquisitions of that "crazy artist" in town were all of the blue-and-white railroad signs proclaiming the Denmark, South Carolina, stations. These porcelain plaques are now in constant demand for display as relics of our cherished past.

With the same unthinking haste, a beautiful vintage hotel was leveled to make way for a new, very blue and very yellow auto parts store. I again stood helplessly by as the fading, sweet scent of uprooted wisteria vines became scarcely discernible from the earthy aroma of crumbling handmade brick. As a gift, or maybe as a consolation, the razing owner presented me a key to one of the guest rooms.

Twenty years later, and with much enthusiasm, our town's "Johnny-come-latelies" point with pride to a crudely painted mural of the old hotel. In an effort at historical accuracy, a homemade weather vane extends above the faded painting.

But if they were trying to recreate one of our priceless, dismantled monuments, the members of the mural committee were striving for an unattainable goal. Any replica, mural, historical marker, or other such always has and always will fall short of the real thing.

If only the mural committees of the future could become so aware as to realize that even they, sometimes, destroy. Through the well-intentioned but misguided efforts of our committee, the beautiful old brick side wall of a 1915 grocery store has now been covered over and ruined in order to make a place for "the picture of the old hotel."

An old building is not by any means a bad building, but the modern thinking of many architects and builders seems always to result in

the tearing down of the old in order to make way for the new. I find such disregard for old architecture disgusting, especially when a perfectly sound structure that has served us well for many generations is demolished, only to be replaced by an inferior, characterless, vinyl construction with a life expectancy of some twenty years.

From an ageless treatise on old buildings one can read, "Before pulling down a building in pleasing decay, it should be looked at three times . . . to be sure first, that it has no virtues in itself that will be sadly missed. Second, that it will not be missed as an enrichment of its present surroundings; third, that it might not form a useful point of focus, whether by agreement or by way of contrast in future surroundings."

My reputation as a painter of old things reaches even the junk collectors of this area who, like most people, have no insight into my work, my philosophy, and what I'm all about. Some people are of the opinion that Jim Harrison will buy anything rusted or worn out and stick it in one of his warehouses full of rusted and worn-out old things. Not true. But even though the junk man doesn't know the difference between junk and the things in my warehouse, he should not be ridiculed for his lack of awareness. Many sophisticated museum curators, who should know better, are avidly collecting row upon row of boring old things, which often are no more than junk themselves. Into those monotonous glass cases are crammed many items identified only by the periods of their use.

Carefully arranged year by year are item after ridiculous item. I apologize, but listen, age alone is not reason enough for their being there. A look backward must investigate not just what it was, but also how it was used, the way things were done, and how people thought. Then, and only then, can we begin to sort out that which should find its way into the museums, the historic trust, and books such as this.

Similarly, while we are taught respect for the older generation, we should remember that age is merely a measure of time from birth to the present. Gray hair and wrinkles of the years, like weathered wood and rust, should not, alone, command respect. Not at all. High regard should be reserved only for the knowledge and experience accumulated over those years.

Wisdom does strongly dictate, however, that vintage things and old ways must be appraised according to their value, and possible continued usefulness, before they are discarded. We must take extreme care not to destroy our irretrievable treasures and verities.

# Before The Stores

"Scuttles and cans, buttons and bows, / I'll cure your ills and cheer your woes," cried the pack peddler as he worked his way through the rural countryside. Traveling afoot, by horseback, or, only rarely, in a wagon, these colorful characters represented the first faint movement of commerce in our country. Early peddlers served as one of the few links between the well-populated eastern seacoast towns and the inland rural farms.

The isolated yeoman, located far from civilization, provided sales opportunities for enterprising men whose minds nurtured thoughts of profits and riches. No one in the rural areas was

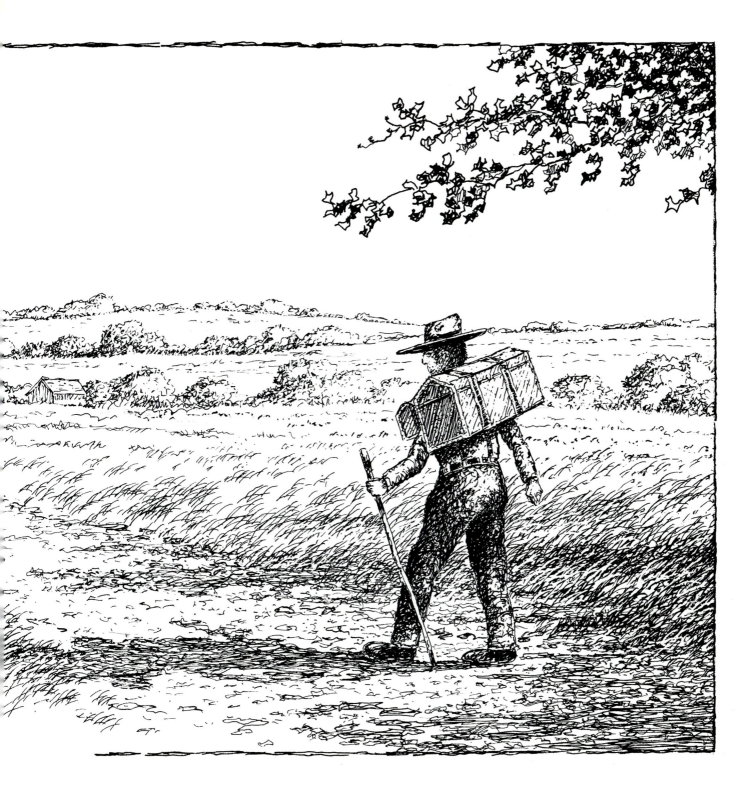

completely self-sufficient; farm families could not live totally from the land. Some things were impossible to grow or to make on the farm, and the peddlers were the exclusive sources of such goods. These inland markets were irresistible territory for keen, ambitious salesmen.

As quickly as the farmers settled and established their spreads, men with strong backs strapped on their trunks of goods and headed out to follow. The markets for these walking salesmen were expanding, and the demand for their goods was increasing.

The life of a peddler on the road was rough and lonely. It appealed only to those with a spirit of adventure, a hankering to travel, and a consuming desire to be successful. The business

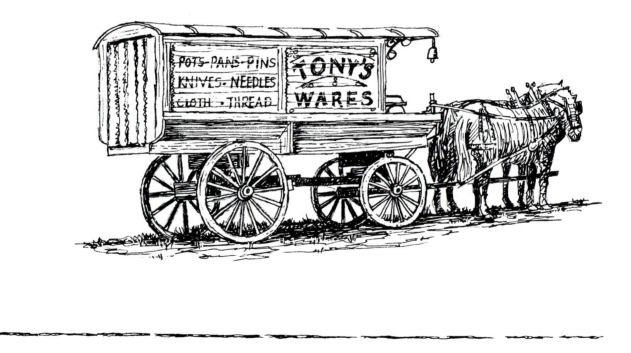

10

required very little start-up money and no previous experience. Ten dollars was more than enough to stock his packs, and the peddler learned his trade as he made his way.

In the spring, winter-weary farm families eagerly awaited the man with the packs. Always he was a welcomed guest, and all work stopped when he arrived. Everyone gathered around as he opened his packs and spread out his wares. Never in a hurry, he relished the opportunity to rest himself, eat a home-cooked meal, and, often as not, spend the night. As he showed his goods, he entertained his potential customers with news from the coastal areas and with stories of his travels.

Hours of walking alone provided him the opportunity to polish his sales abilities, and that he did. As one historian has put it, "The peddler's sales pitch would cause wants to dawn on the household that they had never known before."

The families usually had, ready in hand, a list of items they had to have, and the trading sessions were quite lively. Since his products included things the family could not do without, the seller was in a position to get the best from every transaction. Even poor farmers were anxious to add an occasional luxury to their meager possessions, so their sales resistance was low.

Isolated and uninformed, the rural people usually paid the peddler excessively high prices, which he quickly blamed on the greedy, big-city merchants. Likewise, he undervalued any farm products which might be offered to him in

barter. He occasionally took in exchange, against the purchase, an old book, used furniture, or a piece of pewter. These trades were perhaps the first deals in American "antiques."

Carrying a long, narrow, fifty-pound tin

*"It has been said that a picture is worth a thousand words, but as I face a blank sheet of writing paper I begin to question the validity of that old maxim. One thousand words is hard to come by. Blank paper like a blank canvas is scary. The first word, like the first brush stroke, is the hardest."*

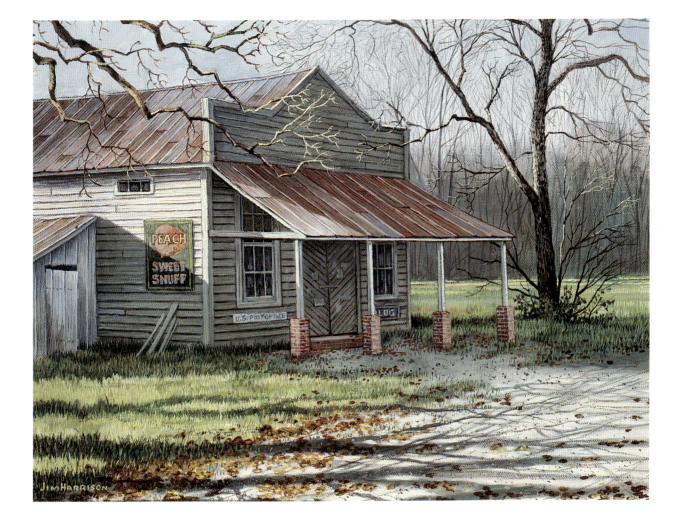

13

trunk on his chest and a heavier one on his back, the foot peddler had to be a master at packing his wares in order to get as much in the limited space as possible. The first peddlers stocked a general line of housewares and notions; tinware, hardware, thread, buttons, thimbles, and needles were among the best sellers. Higher profits came from lace, fancy clothes, spices, mirrors, tea, coffee, and spectacles. Jew's harps and folding penknives received the highest admiration, but were among the least-needed items.

As the rural roads improved, peddlers built ingenious carts which could be pulled or pushed. Some were able to pay sixty-five dollars for a horse and wagon. But to take advantage of the wagon, an additional three-hundred-dollar investment was needed to buy inventory. A wagon peddler could travel some fifteen to twenty miles a day and cover several hundred miles in a few months. These improvements in transportation increased the peddlers' importance in our early commerce. They were able to travel further, have more stock available, and trade or barter for a greater volume of farm goods.

These "walkers and hawkers" were the rural distributors for the manufacturers of the day, and thousands of small farm families depended on them to supply their needs. It was the early peddler who kept alive in the sparsely populated areas the first stirrings of our industrial expansion.

Unlike the small farmers, the antebellum plantation owners needed larger quantities of manufactured goods and depended on a different method of receiving them. Plantations were usually located near navigable waterways so that cash-producing crops could be barged to the nearest seaport towns. Access to river transportation enabled the large planters to receive shipments of supplies in great quantities.

Even though land-rich and financially successful, plantation owners were often short of working capital, and they required considerable credit. American-based purchasing agents served as the middlemen between the planters and the cash-rich, overseas buyers. These middlemen, known as factors, arranged credit using the anticipated crops as collateral.

Factors lived in the shipping ports and would use the planters' credit to purchase and ship the supplies necessary for making the crop. This development tended to concentrate a majority of the trading activities in only a few coastal towns. As a result, there was neither need nor opportunity for established small mercantile outlets in rural antebellum America.

14

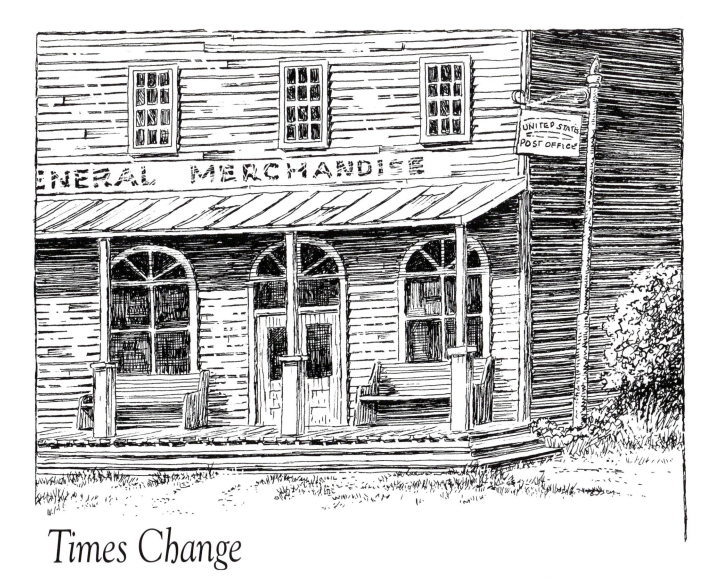

# Times Change

The heyday of the country store spanned the years between 1865 and 1930. No other institution had more influence on the lives of rural Americans.

Relegated by most writers and historians to the category of quaintness, the store deserves more attention than that. Having earned its rightful place in the history of business and the development of society in this country, it can stand on its own merits. Any telling of our nation's story would not be complete without including a discussion of the various functions of these venerable crossroad emporiums.

Fondly waving his arms in the direction of

15

*"Being able to paint and write as I please is a rare privilege. I enjoy an uninhibited way of life with personal satisfaction that could never be found in the business sector. Making my living with brush and pen is a dream come true, and I long for the day when I am shed of all other interferences and responsibilities."*

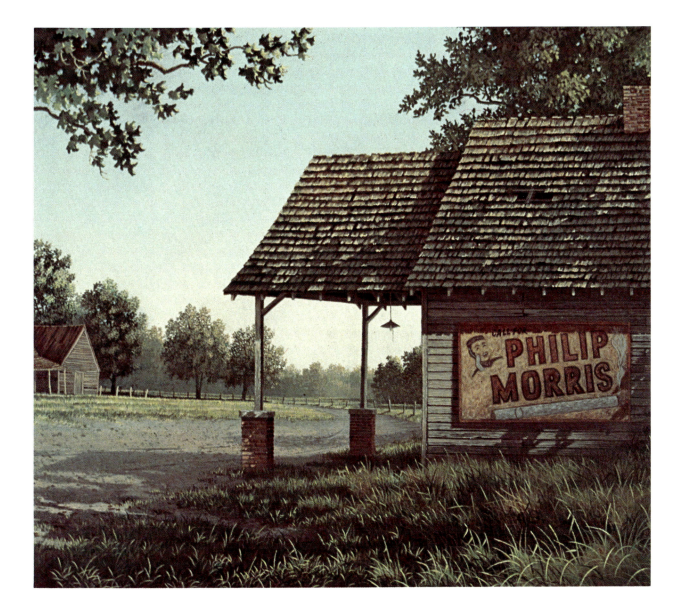

the abandoned building, an elderly black gentleman of my acquaintance said, "To town? No sir, we didn't go to no town. There weren't no town far as we were concerned. This was our town righ' chere. What's we didn't raise or make, we bought righ' chere, at this store. Yes sir, I didn't see no other store till I was growed up," he continued. "We could get all our Christmas and even the things for birthin' and buryin'. Righ' chere. Yes sir, I mean, everythin'. We didn't need to go nowheres else. I'll tell you somethin' else too, mister. Anythin' that ever happened in these parts, happened righ' chere. Either they happened or you heared about it mostly faster than a radio would tell you. Yes sir. This was our meetin' place. The white folks a come here too. Just like us. I reckon they didn't have nowheres else to go either. I guess there weren't no towns for them. They was in the same boat as us."

After the war between the North and the South, many of the large southern plantations were divided into smaller farms, which resulted in the deterioration of the plantation-factorage system. An increase in the demand for merchandise in smaller quantities created the proper atmosphere for the opening of crossroad country stores. So began what would become a nationwide financial and marketing revolution.

Little cash existed in the rural, land-rich South, but the newly freed, able-bodied slaves and the poor landless whites needed employment. The freedmen, once totally supported by their owners, were now responsible for their own bed and board, but cash-paying jobs for laborers were not available. Out of this period of depression and disorganization emerged the new era of the tenant sharecropper.

Landowners entered into tenant agreements that typically assigned the former slaves twenty-five acres to tend. The sharecroppers were provided a tenant house, and credit was arranged at the local store for food and living necessities. In exchange for a percentage of the crop produced at harvest time, these sharecroppers and their families furnished the labor.

The tenant sharecroppers and the small white farmers, as a group, numbered in the millions during the postbellum era. Their expanding need for small amounts of goods on a regular basis was reason enough for the profit-minded to open stores, and that they did.

"I'll pay you Saturday" is a curse to the small businessman of today, but in those times it was the storekeeper's salvation. The country merchant became the primary supplier of the farmers and sharecroppers, who purchased all their goods in limited quantities. The store owners, who bought their inventories on long-term cred-

it, recognized the additional interest-producing potential from selling "on time." Interest rates as high as two hundred percent were common.

Seizing another opportunity to make a profit, the storekeeper positioned himself as an agent for the cash crops. He became the middleman, linking the farmers with the seaport buyers. This arrangement elevated the store owner to the powerful position of buyer, seller, and financier. The farmers, the wholesalers, and the seaport exporters became increasingly dependent upon him. The crossroad stores rapidly came to the fore as the heartbeat of a large portion of the nation's business.

Slavery was over, but the bondage of segregation remained total in the schools and churches. For whatever reason, racial bias first began to disappear in the marketplace, and the country store was more integrated than any other institution during that time. Whites and blacks shopped together daily, and the freed slaves got their first taste of equality. A certain kind of relationship develops between a buyer and a seller, so blacks, as customers, were served right along with whites. All patrons were at liberty to try on shoes, hats, and other pieces of clothing.

Whites who would never have thought of socializing with blacks in their homes, schools, or churches spent time interacting with them at the store. An atmosphere of familiarity, bordering on friendliness, prevailed between the races at these trading places. Such was the beginning of desegregation.

The passing of time has confirmed that these isolated markets were much more than places where merchandise was bought and sold. At a time when much of the nation was in a state of transition and turmoil, the country store rose to the occasion and made major economic and social contributions. It did its job well.

"*Art without emotion has no meaning. Subject matter is extremely important to me. I have much love and respect for every object I paint.*"

20

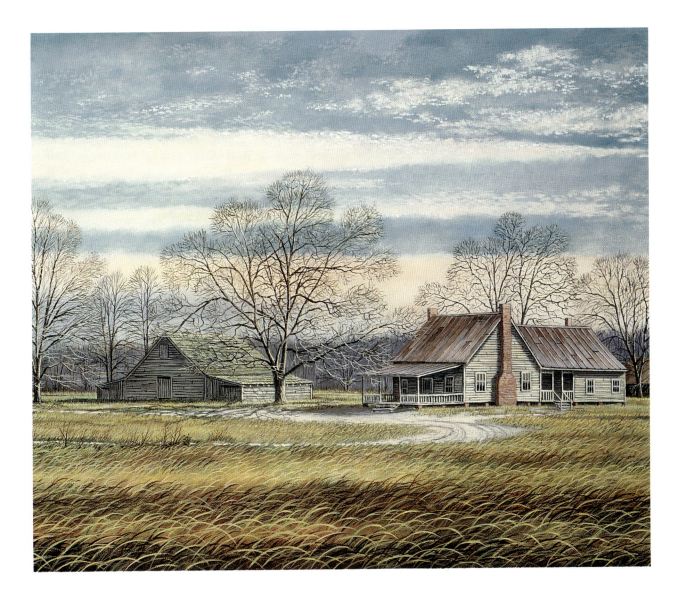

21

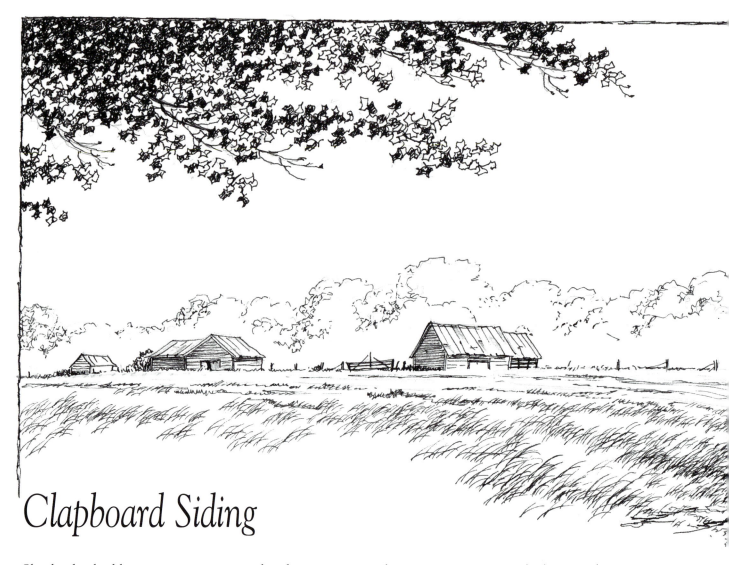

# Clapboard Siding

Slowly the buildings are giving in to the thousands of summer suns and the freezing winter rains. Nestled in the grassless sand or propped upon hard bare ground, long-abandoned country stores stand under huge old shade trees, their faded sides visually pealing out, "Drink Coca-Cola." Appearing to have been a part of the landscape forever, they have weathered and worn their way into a natural place in the surrounding environment.

"It's been there just about as long as I can remember," an old-timer will say. "It goes a way back." Well past their prime, the old edifices are monuments to times and temperaments long since gone from the commercial mainstream.

A sense of pride abided in the hearts of rural

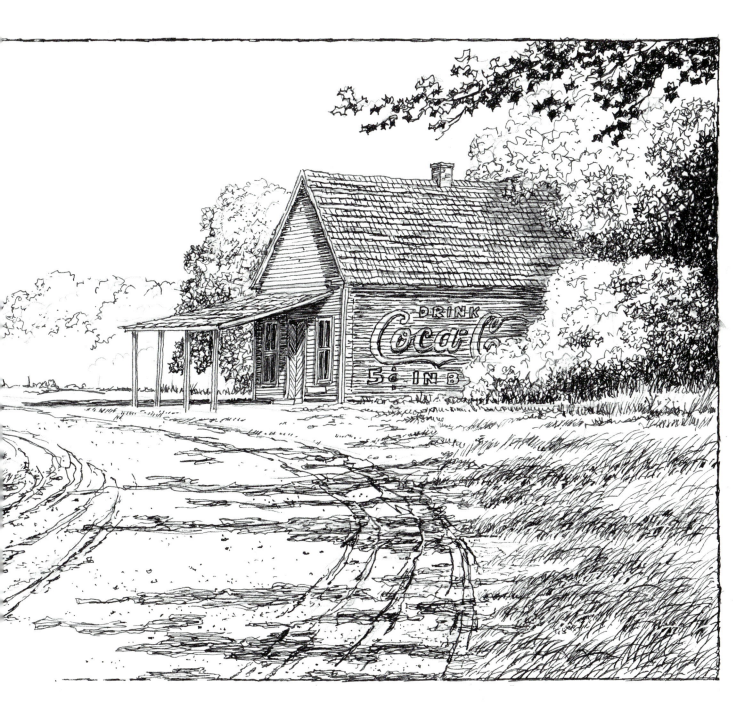

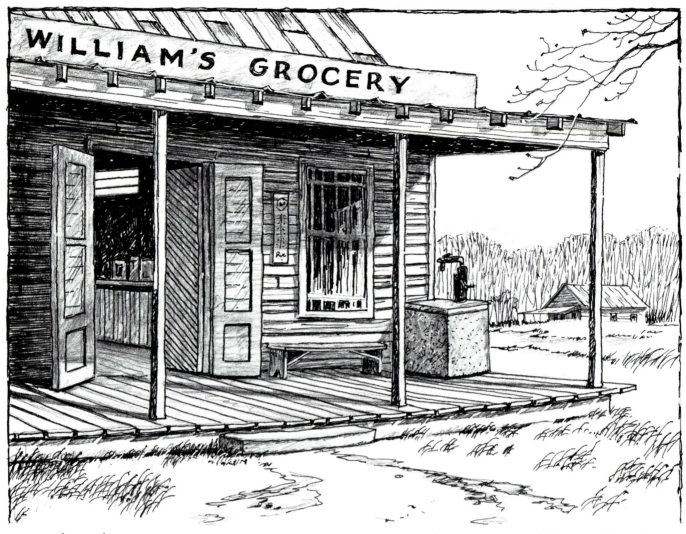

people, and store owners were no exception. Appearance was important; it was a matter of simple dignity to keep up a good impression, however superficial that might be. So it was with the stores. The smallest of buildings would flaunt a front that gave the impression of a much larger structure behind it.

The fake facades, which extended upward and hid the shingled, gable roofs, offered the one opportunity for uniqueness of design. The tall faux front gave a vertical look to an otherwise square building and became the identifying mark of such structures throughout the rural countryside. Wood-frame clapboard construction permitted easy expansion as business increased, and wings and sheds were added to the sides and backs for stocking heavy implements. These barnlike structures preceded the brick building

era of the early part of the twentieth century.

Some of the larger stores had a second floor, where they often stored and displayed coffins and caskets. On occasion, however, a rather unique arrangement was made with a local fraternal order, such as the Masons or the Woodmen of the World, whereby the store owner paid for building the bottom floor, the fraternal order paid for constructing the top floor as a meeting room, and the two shared the cost of the roof. The symbols of those fraternal orders even now remain visible on the facades of many of the structures.

Front porches were a familiar feature of the stores, and years of sitting, shifting, smoking, and spitting have worn them well. No two boards remain level or parallel, and the posts supporting the roof are likely to tilt in different directions.

To serve as a warm-weather, outdoor forum for the discussion of local matters and gossip was an unintended but vital function of the porch. Ingrained in the sagging tongue-and-groove floors are timeless words of weather, politics, religion, and crops. The wisdom of Wilson, Coolidge and FDR still echoes from the past.

The porches were built several feet above the ground, just the right height to serve as the loading and unloading docks for the many barrels, bags, and boxes that passed over their flooring into waiting wagons.

## FAKE FACADES

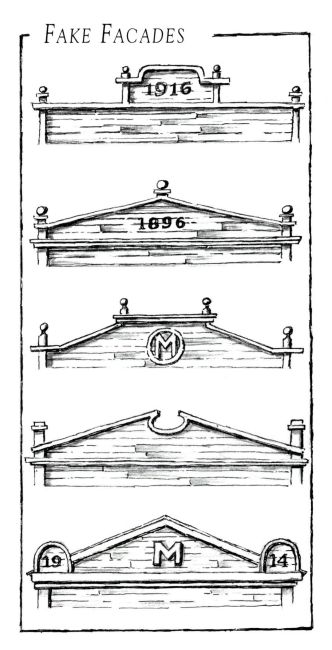

*"Memories certainly play a part in my work. I can vividly remember moments from the summer months of the early 1950s when I painted Coca-Cola signs on the walls of country stores. People can learn and know about places and things from books or photographs. That's gaining knowledge, and is full of facts. I'm talking about remembering, which is quite different. We remember with emotion what we experience. Most of my painting efforts have been an attempt to rekindle certain experiences of my past."*

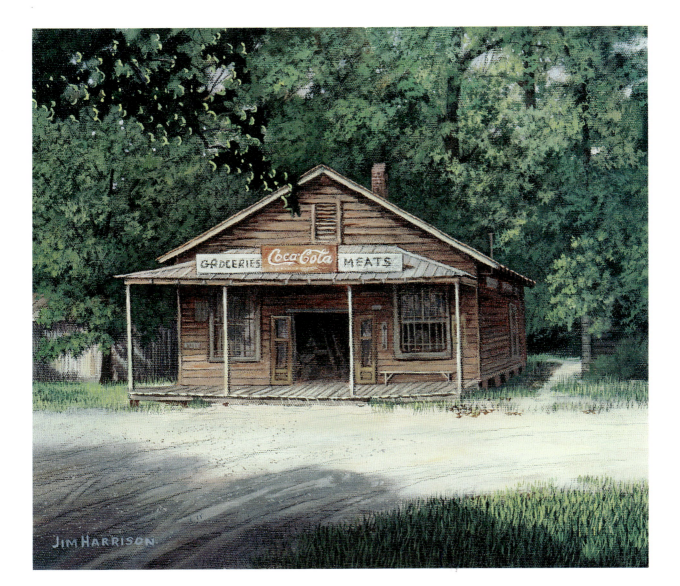

27

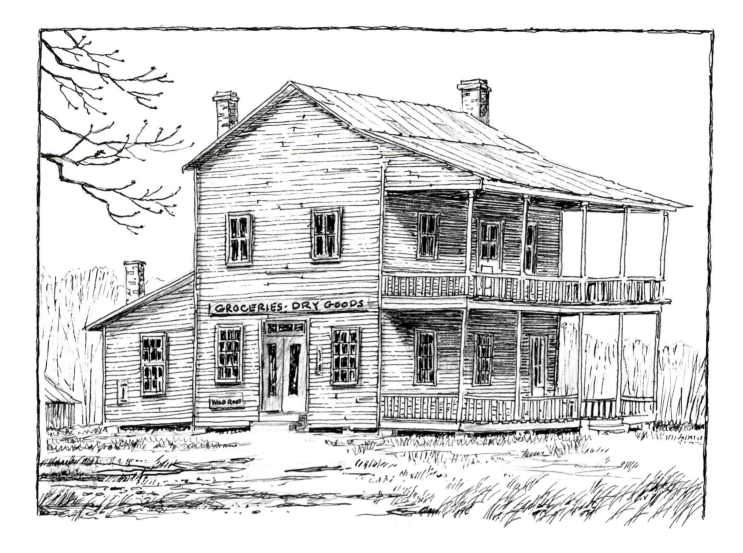

Doubling as the unofficial community bulletin board, the heavy front door of the store bore the scars of hundreds of nails and tacks. Sheriffs, auctioneers, church folks, and anyone else with an announcement to make used the front door. Even hand-written funeral invitations, once a rural burial custom, found their way to the doors.

The large front entrances, flanked by heavily barred windows, did little to break the monotony of the symmetrical facades. Doors, windows, and shutters were swung open during warm weather, but were closed at night and heavily secured by bolted iron bars. Such fortification questioned the validity of the ever-present sign announcing, "Through These Doors Pass The Best People On Earth, My Customers."

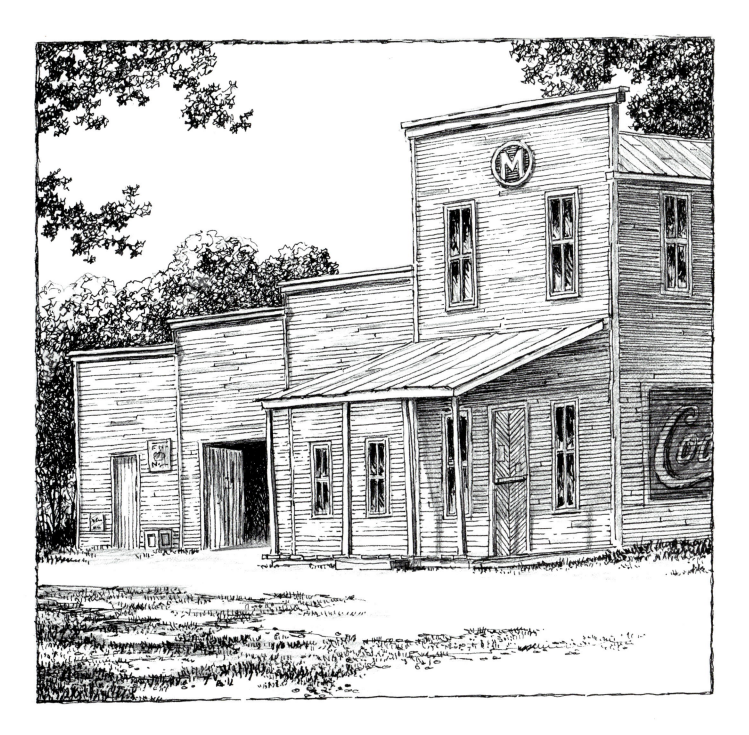

29

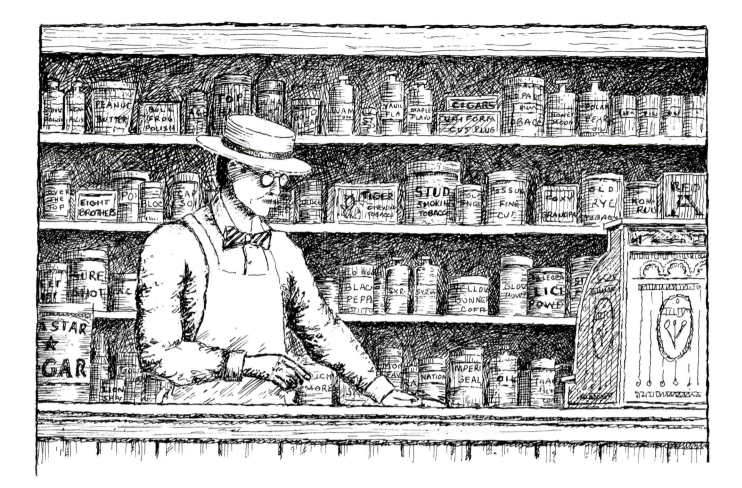

# Retailing Philosophers

Philosopher, philanthropist, weatherman, adviser, financier, and merchant—the storekeeper's life was never boring. From his office area behind swinging lattice gates, that man of unending energy and wisdom kept a daily reading on the pulse of the community. Usually regarded as the most prudent person in the area,

he was highly respected and trusted. For the uneducated he read and wrote letters, interpreted important papers, and willingly stored in his office safe their money and valuables.

Serving as the people's lifeline in both good times and bad, his own ability to survive went unquestioned. Weathering failed crops, depres-

sions, and other adversities, he endured, and by word and deed encouraged others to persist.

This early-American, penny-pinching, workaholic always controlled his own spending while advising others to do the same. Subscribing to the cardinal rule that all must pay their debts, he maintained a strict, conservative approach to credit, not only for himself, but for others.

Close familiarity with his customers made him aware of their frailties, yet so often it was to him they would turn in time of financial need. Maintaining firm control over credit he granted to his customers was not an easy job, and he always had to be on guard so as not to "run his business with his heart." Making sound credit extensions depended on his knack for judging his customers' character, honesty, and ability to pay. A variety of humorous signs and messages, like "Pay Up or Shut Up," were stuck in and around the store. "I'll pay you Saturday" didn't always mean next Saturday. Since it was not unusual for customers to settle up only once a year at harvest time, the storekeeper had a keen interest in how his customers' crops were doing.

That concern is best illustrated by a story about a store owner and a "chicken-raising customer" who was well over $500 in debt for feed when the chickens took sick. The store owner not only furnished free medical advice and medicine, but sat up at night with the farmer and sick chickens until the birds were cured and his $500 investment was protected.

Computers, statistics, projections, and plushly furnished board rooms were unknown to him. A flat, tablelike work area, a rolltop desk, a stool, and several chairs and ledgers equipped his open office area. The absence of walls and a door meant little privacy for the discussion and transaction of business. Conversations with customers about credit and other matters took place there, but the talking was slightly above a whisper.

Much of the storekeeper's time was spent in public affairs and in the lives of his customers and friends. His hardworking mind took note of their likes and dislikes; he knew their shoe sizes, chest measurements, and color preferences. The kinds of soap, the foods they liked, and to what extent the ladies dipped their snuff—all this and much more was known to him, and a shopping list needed not include brand names or sizes. But though he was capable of retaining so much information, he still did not allow profit to depend on memory.

All sales or exchanges in barter included the potential for negotiation. So that he could quickly determine the cost of his goods, he

*"I've often wished I could have lived during a time when men were more directly responsible for their everyday things. A fire is nicer if you cut your own wood. A candle produces more pleasing light than an electric bulb. I'll take cool well water over city water any day. We are fast losing the awareness of good things. Today we cut on a light switch or get water from a faucet with no knowledge or concern for where it came from or how it got here."*

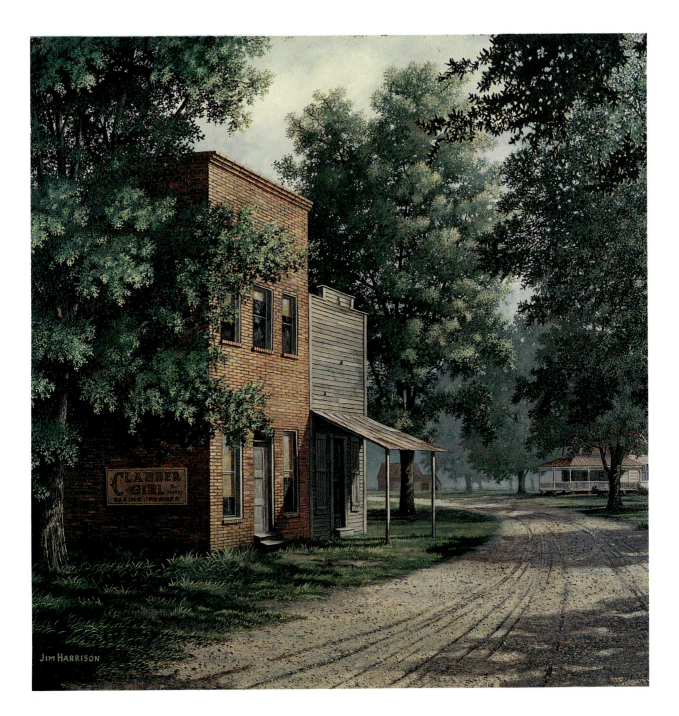

33

price to be $3.56. This system allowed the storekeeper to know his cost, to negotiate on the spot without having to refer to his records, and to trade profitably.

This bottom-line capitalist was constantly at work on his books and ledgers when not serving or talking with customers. Using self-devised systems of record keeping, he made charges against accounts, computed interest, and posted payments.

Eternally busy and often hurried, he was the symbol of stability—always around, always helpful. He had come to stay and had put his money where his mouth was. A well-stocked store represented a considerable financial investment, and just being there was evidence of his commitment to the community.

Since the store was the cornerstone around which the community grew, it is not hard to find crossroad communities bearing store owners' names. But you will not find marble monuments erected to those turn-of-the-century merchants, nor are they documented in history books. The vestiges of business history may be filled with his truisms, but none are attributed to him. His survival was his legacy, and nowhere else is there a better example of Ben Franklin's philosophy, "Take care of your business and your business will take care of you."

marked them with a letter code. The method consisted of ten-letter words or phrases in which none of the letters were repeated. Some of the favorites were "misfortune," "black horse," "fish tackle," "cast profit," "so friendly," "white sugar," "gainful job," and "now be sharp." Each letter stood for a number, one through ten, and the storekeeper would designate for himself which letters indicated the product's price. For example, in the phrase "fish tackle," if the s, t, and a were the key letters, the owner would know the

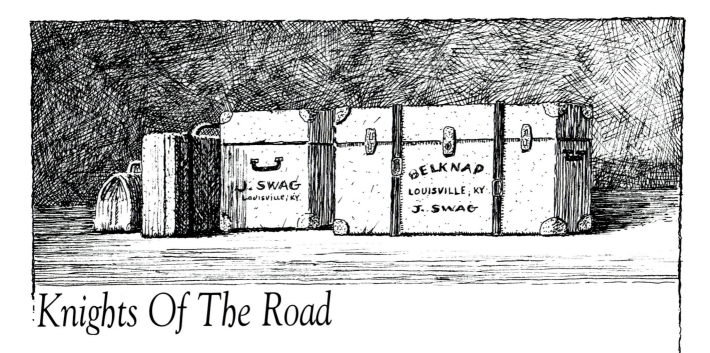

# Knights Of The Road

Late-nineteenth century opinion did not consider it in good taste for respected businessmen to go out and solicit sales. Big-city wholesalers had elaborate showrooms for local customers, but relied mainly on their mailed catalogs to sell to the distant rural outlets.

However, noting the success of the wandering retail peddlers, aggressive and creative wholesalers began testing the potential for company-sponsored traveling salesmen. Despite their earlier attitudes, other houses soon followed suit and began sending men out to distant retail outlets to "drum up" sales. Known as "drummers," they were not immediately looked upon with favor, but the prejudice against those mobile traders slowly diminished. In time, competition forced even the most respected and dignified wholesale companies to take their products to the customer.

Those early "knights of the road" were colorful characters, usually with a penchant for flashy dress. Bright neckties, heavy pocket watches on gold chains, and diamond rings were obvious signs of success and class. But no matter how exciting their lifestyle might seem to have been, the job was not easy. Financial achievement resulted from hard work and determination; the gaudy clothes and jewelry came afterward.

In his nineteenth-century diary Charles Plaummer outlined the requirements for a successful drummer: "The commercial traveler is himself an organizer, a governor, and a civilizer. He must be a natural orator, a master of the art of pleasing, a genial companion, a politician, something of a statesman, a good story-teller, a walking encyclopedia of prices, an

"*It is important to know when to stop. I have, many times, made a quick color sketch only to ruin the results by overworking the painting with detail and craftsmanship. It happens with writers and speakers as well. We seldom are willing to stop when we are ahead. My preliminary rough sketches usually include more of me and my creative ability than the finished paintings.*"

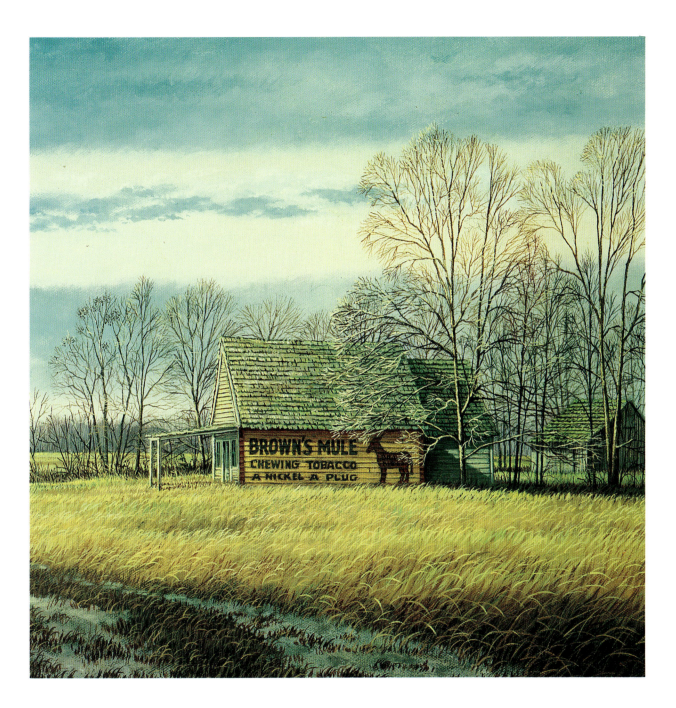

authority on taxes, and a good salesman."

Drumming was a job for the young and ambitious, men who constantly pushed themselves while learning the art of marketing. Their ultimate goal was usually a settled administrative position with the home office. Their work kept them away from home for months at a time as they enthusiastically pressed forward to the next town and new customers.

Traveling without the luxury of a Pullman berth, drummers rode all night upright in a train seat, but were in a selling mode early every morning. Railroad travel was expensive, but no better bargain could be had than that offered the commercial traveler by the small-town hotel. One dollar would purchase a night's lodging, meals, transportation of his large trunks, and, often, display space in the parlor.

His route was planned well in advance, and he always had a confirmed reservation at the local hotel. Before arriving, he would have mailed area storekeepers invitations to visit his hotel display. A night of ordering merchandise was usually spiced with the drummer's stories and maybe a sip or two from his special bottle of brandy or whiskey.

Several two-hundred-pound trunks of samples and numerous catalogs, offering an even broader variety of buying opportunities, were with him everywhere he went. When not displaying in the hotel, he rented a horse and carriage from the local livery stable and called on merchants unable to visit him. He took their orders and arranged a credit plan, though cash on delivery or immediate payment was sometimes required of new customers. A real stickler for accurate records, he faithfully forwarded by mail or telegram a daily accounting of sales and expenses to his company office.

Through the years, transportation and communication have vastly changed the life of the drummer, but the traveling salesmen of today subscribe to the same goal as yesteryear's pioneer road merchants. Theirs was the task of bringing to the storekeeper new items, new gadgets, new ideas, and to keep those products moving from the manufacturer's plants and warehouses to the display areas of the stores.

Plaummer continued in his diary, "The drummer made possible the building and expanding of factories. Without his sales the labor force would not have been necessary to satisfy the need for goods." Yes, the drummer saw himself as the starting point in the movement of merchandise. Debatable is his claim to all the credit, but certainly his was a necessary task—and one reserved for the hearty and ambitious. His was the job of the real traveling salesman.

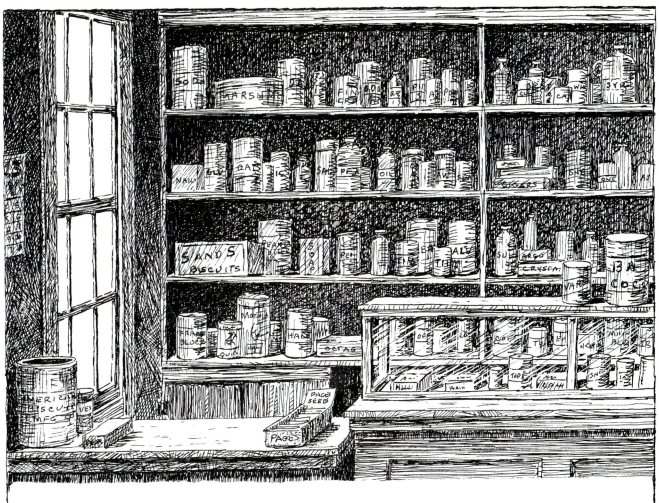

# Organized Clutter

Disorganized organization cluttered the interior of the store, which looked as if it had never seen a carpenter's level. Floor-to-ceiling shelves ran parallel to nothing, not even each other. An uneven, long-settled floor continues to support heavy, heart-pine counters that local craftsmen built to last forever. Painted many times, but not once within the last fifty years, the greasy, notched and chipped counter tops have been worn smooth from thousands of packages and hands sliding across the surface. Still recognizable are most of the tack heads that were pushed into the counter at one-inch intervals to serve as a measuring guide when

two traders "got down to brass tacks."

Polished by foot traffic, silvery nailheads and tin patches covering holes in the century-old floor look almost new. Leaning interior support posts seem to offer little resistance to the tilting building. Touched many times by dirty hands, a cardboard light pull proclaiming Wrigley's Spearmint Gum dangles and turns on the end of a string. Stretched door springs no longer have any pulling power. Every inch of space was used, and every exposed nail had something hanging from it. A real housekeeper's nightmare, yet cleanliness was the eternal goal. "You can bet this place had been hand-swept and dusted every day, except Sunday, for over sixty years 'cause I done it," one of the owner's helpers said. "The boss wanted these aisles clean of dirt, and no dust sure better not get on the merchandise."

A hodgepodge prevailed with a system known only to the storekeeper himself. A faint semblance of order existed near the front door in the place of honor reserved for the United States Post Office. Upon entering that holy enclosure, the merchant instantly became a federal official and was protected not only by the oak barricade and heavy homemade bars, but by the U.S. government as well. The storekeeper/postmaster had a healthy respect for postal laws and passed that reverence on to his customers.

The slightly awed public was kept well beyond the confines of the government's portion of the store, and only the postmaster was allowed access.

Customers carried out their transactions with the government in a cautious, official manner through a window centered in the oak-paneled partition. Few customers realized that the postmaster's pay was usually the revenue he generated from the sale of stamps.

Extended around the interior perimeter of the store were the heavy sales counters. Designed for the comfort of ladies wearing voluminous hoopskirts, the thick top boards extended well out over the front which sloped back toward the bottom. Long after hoopskirts were out of fashion, carpenters continued this obsolete method of construction. Behind the counters the merchant roamed in his official "no man's land."

His was largely a job of cutting, weighing, wrapping, and tying, as the early shoppers had few choices of packaged brands. Most food supplies were either dried or salt-preserved and delivered to merchants in boxes, crates, kegs, buckets, or hogsheads. Grain, flour, and other loose commodities were shipped in cloth sacks until the Civil War created a shortage of cotton. This shortage stimulated a demand for a substitute, and the paper bag was developed. The bulk

products were stored in the shipping containers, barrels, or in bins behind the counter. Customers simply asked for a "slab of bacon," "a bag of flour," "a pound of rice," or more often "a nickel's worth." An order for a handful or fistful left the computation totally up to the merchant.

The salesman measured out the items and wrapped them in brown paper, hand-fashioned bags called "pokes." An experienced clerk could do this with one hand, sometimes using string from a roll attached to the ceiling. Eventually the store owners recognized the paper bag as a relief from the tedious wrapping and tying jobs, and by the mid-1870s paper bags were in extensive use.

A study of the country store inventory reveals the evolving history of lifestyles, tastes, and needs. Early on, rural people cultivated and raised a majority of their food and made by hand most of the other things needed. The store stocked the tools and implements required to accomplish that. Other items that could not be manufactured at home—tea, coffee, cloth, thread, and pots and pans—were mainstays in the store's inventory. As the rural areas devel-oped and the economy became more diversified, so did the offerings of the store. It is hard to think of something they did not handle at one time or another. Through the years they sold the necessities and the niceties, the practical and the pleasurable. Merchants began especially to stock more foodstuffs, not only the basics but the processed, "ready to eat" products as well.

As people began to shop more frequently, they did not buy in such large quantities, and the barrels and bins with their bulk contents began to be looked upon as unsanitary. The wholesalers and distributors sensed this trend and attempted to create customer demand for their particular product. One of the earliest and most successful attempts began in 1898 when the National Biscuit Company removed the open cracker barrel and replaced it with pack-aged Uneeda Biscuits. Thus began the age of individually packaged and canned goods.

Lining all except the front walls were shelves stocked with Octagon soap, Calumet baking soda, dishes, and bolts of cloth. Blue Horse school supplies, pencils, and ink were stocked

*"With my art what you see is what you get. I hope that my paintings need no explanation. I simply want to communicate my message to the common man on the street who claims to have no knowledge of art but does know what he likes."*

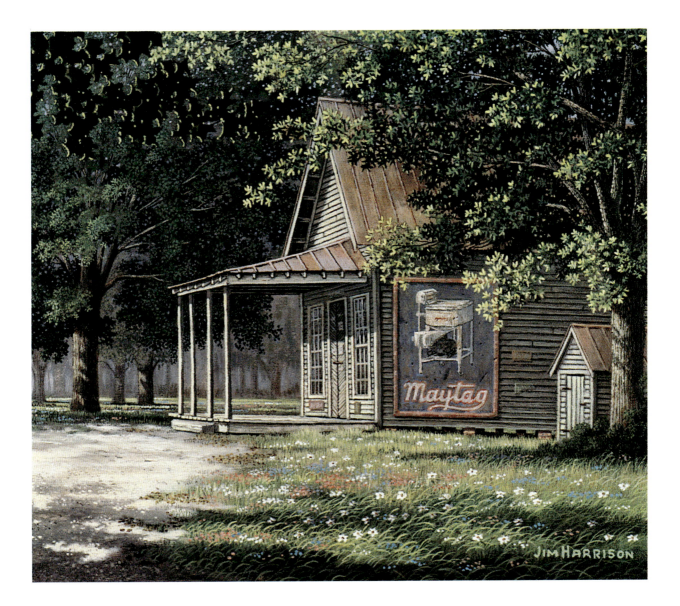

43

beside the Webster's dictionaries, Bibles, and free Old Farmer's Almanacs. An ample supply of turpentine, sweet oil, and epsom salts were stored in the patent medicine section. Displayed too boldly for the comfort of mindful youngsters were the big blue glass bottles of Milk of Magnesia and Caster Oil. A variety of headache powders competed for the customer's attention and money by guaranteeing the fastest relief possible.

In time, improved glass showcases crowded out the wooden counters, and competition for sales prompted companies to furnish their own showcases and cabinets. Cookie jars, thread and needle cabinets, and tobacco and cheese cutters, all sporting a brand name, jostled for prime selling locations in the store.

Sturdy tables filled the center aisle with stacks of socks, gloves, long johns, and brogans. American-developed and American-made, denim overalls were the basic clothing for the working man, and therefore commanded more than their fair share of space on the front table.

Levi Strauss, a Bavarian immigrant, dreamed of making his fortune by manufacturing canvas tents. He bought a quantity of heavy canvas tenting material from a manufacturer in De Nimes, France. Americans quickly ran the words together, and soon the heavy cloth was called denim. The young entrepreneur did not find the demand for his tents to be as great as he had anticipated, nor was he using his supply of denim as rapidly as he had hoped.

One day he agreed to make a pair of tough-wearing pants out of his heavy tenting material for a hardworking friend of his. As he expected, the fabric proved to be tough and durable, and soon Levi was in the business of making work clothes. Catering to the needs of the workers, Levi added large heavy pockets, but he soon discovered that they caused tearing at the corners. Today, the still-popular brand has the trademark rivet of the early trousers.

Near the back of the store were the odd lots of heavy hardware, plows, wagon spokes, buggy shafts, and tools. Rope, twine, chains, and a variety of axes, shovels, and rakes added to the welter of buying opportunities.

In a prominent position in the center of the store was a big, circular potbellied stove. It served not only the practical function of providing warmth for the store; it was also the cold-weather melting pot for community religion, politics, and all unsolvable issues. This gathering point for hospitality and camaraderie was also the local clearing house for everyone's business. Stoveside discussions included any and every subject imaginable to an agrarian society,

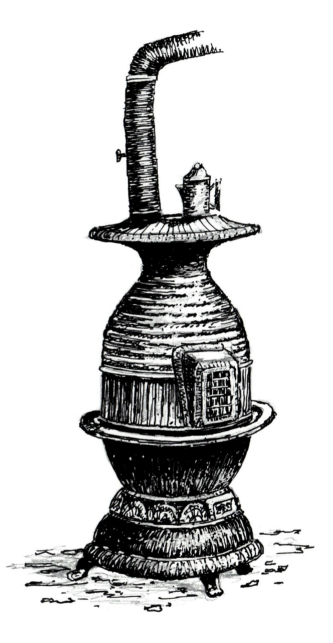

and every day some of the world's toughest problems were solved with an authority beyond question. If only rural areas had been able to accomplish in deed what was accomplished by mouth at the stove. All too often, however, this informal forum could not rise above plain old gossip, and only on occasion did the conversation offer enough wisdom to prompt a youngster to listen and contemplate the meaning of the old sayings he might hear: "A bird in the hand is worth two in the bush" or "A friend in need is a friend indeed."

Kegs of nails and horseshoes had a designated storage place elsewhere, but inevitably they seemed to work their way around the stove, providing additional sittin' places. Within reach of a "johnnycracker and cheese," one could draw up a seat, light up a pipe, chat, dream, and enjoy the warmth of an oak fire.

Perhaps to the delight of the store owner, the potbellied stove vanished with the advent of central heat. But for those remotely located, lonely country folks who valued the closeness of community and the sharing of ideas and opinions, there was never an adequate replacement.

Around the potbellied stove were spun the yarns of the early cracker-barrel philosophers. There were solved the problems of the day. There was the essence of the crossroad country store.

"*We do identify the real us by the objects we surround ourselves with.*"

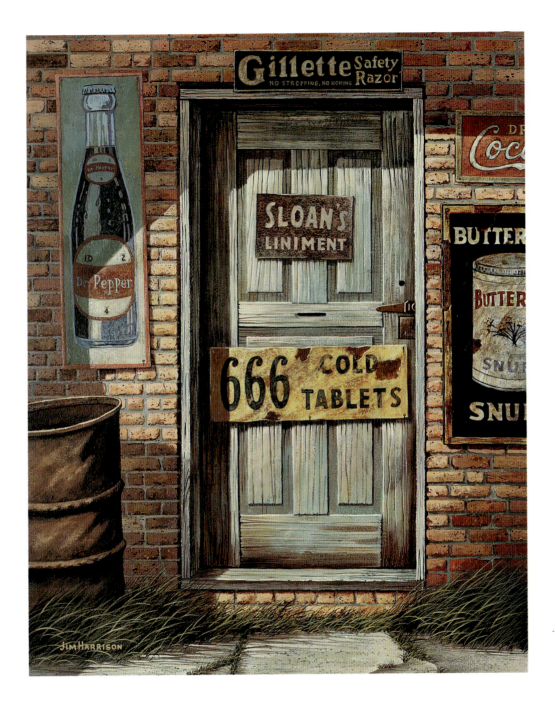

47

# Whittling, Chewing, And Checkers

Every man toted a knife for whittling, chewed tobacco, and knew how to play checkers. Those beloved, indolent pastimes, even at peak performance, only slightly improved upon idleness. Whittling was an aimless diversion that often served merely to prevent the knife handler from having to look up while discussing matters at hand. Using razor sharp Barlows, most whittlers just made long, thin shavings that curled up around their brogan-clad feet.

Some of the craftsmen would cut out crude forms and faces, only to smooth them out again, but most found satisfaction in making long, burnished surfaces. A few of the more ambitious knifemen did use the time and effort to hack out wooden pegs for later use in the

construction of buildings and furniture. A day of stove sitting and conversation could, without thought, net a number of "wooden nails" fashioned to "just about the right size." The bad-weather peg-makers accumulated a variety of lengths, later sorted and stored on workshop shelves.

Only a fine line elevated a carver above a whittler, and that line was usually drawn by the purpose of the project. The more sensible-minded carvers used their efforts to design wooden spoons, toys for the children, or other practical and useful objects.

Most every area did have at least one woodworking artisan who stood out from the rest. Close kin to the "ship-in-the-bottle maker," those patient knife sculptors hewed the ends of walking canes into amazing pieces of art or curiosities. Beginning with a design drawn roughly on a piece of cedar limb or on a long strip of soft wood, the carver formed wooden balls that would roll unimpeded through gouged-out round or square cages. Single or, even more complicated, multiple lengths of a wooden chain further added to the stoveside carver's reputation. This popular form of knife-work, known as chain carving, has endured throughout the rural areas for generations.

Many of their artistic creations found a home on the mantles of admiring relatives and friends. The more valued pieces were not exposed to the risk of everyday viewing, but were carefully wrapped in cloth and tucked away in cedar trunks, occasionally to be pulled out and shown to special visitors.

And then there were those who had a knife just to have a knife. An old black man said, "The cap'n, he didn't use his knife for nothin' but cuttin' off tobacco. Then he sharpened it again and again. He kept his knife mostly just for sharpenin' it and checkin' to see how sharp it was. He'd rub it back and forth on one of them wet rocks. Back and forth. Then he wanted everybody to see how sharp it was again."

Whether it was used for demonstrations of skill, to pass the time, or for practical cutting, a man did take pride in his pocket knife.

Signs saying, "If You Spit on Your Floor at Home, Go Home and Spit" and "Smokers and Chewers Please Spit on Each Other and Not the Stove" were prominently displayed, but never taken seriously by tobacco-chewing customers. Sandboxes near the stove and brass spittoons did their part, but could not remove the temptation to spit elsewhere. A tolerant store owner, who sold the tobacco in the first place, was obliged to maintain the arena for the mouth-muscled activities of the participants.

*"I'm frequently asked about talent, and I have a pat answer. Talent is wanting to do something bad enough. The skill of taking paint, mixing it properly and putting it on a canvas in a pleasing or convincing way is a learned process. However, good painting is ninety percent looking and ten percent doing. If there is a talent, it has to do with the ability to select a subject. The true artist is gifted with the sensitivity to see and point out beauty in places and things where others might miss them."*

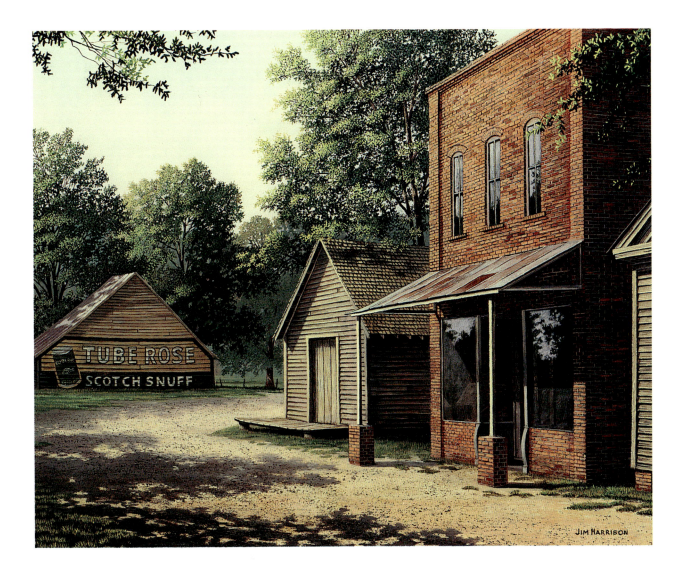

The chance to hit a hot stove with a mouthful of tobacco juice and hear that "sizzling zing" was too tempting to pass up, especially for beginning chewers. Old-timers had their day with tobacco-company sponsored, outside "spitting contests." The prize for distance or accuracy might well be a month's supply of Brown's Mule, Blood Hound, or Bull of the Woods.

It was estimated that by 1900 there were 12,600 chewing tobacco brands, 7,000 smoking flavors, and 2,100 cigar trademarks. The store stocked tobacco products in all forms, including snuff for the ladies.

Early peddlers carried with them "tobacco pigtails," which were wrapped, ropelike lengths of tobacco that sold for several pennies a foot. As the popularity of chewing increased, companies devised a method of compressing tobacco into a form known as a plug. It weighed one pound and could be sliced into "cuts" selling for a nickel each. The tobacco plug cutter, in virtually constant use, sported a warning sign: "Don't Put Your Finger in the Cutter."

Competition for cigar sales intensified by the turn of the century, and two-for-a-nickel promotions coined the word "twofers." Identified and labeled with colorful, embossed trademarks, the beautifully designed boxes contained expensive Havanas as well as the cheaper blended che-

roots and stogies. Packaged cigarettes did not arrive on the scene until the waning years of the country store.

With an effort no more strenuous than relaxing, a game of checkers could get underway. The pastime of kings and pharaohs, so far removed from its Egyptian beginnings three thousand

years ago, found its rural niche near the warmth of the stove with a nail-keg-turned-checker-table. Although checkers was mentioned as a test of intellect in the works of Homer and Plato, the rules of the game of the royal courts were easily understood by poor, illiterate store visitors, whether white or black. The inability to read did not prevent any willing player from drawing a sixty-four square board with alternating light and dark squares. More permanent boards were drawn on the tops of barrels, tables, or even a designated spot on the sales counter. Twenty-four soda-pop bottle caps or whittled pieces of wood stood in for the royal version of red and black disks. Games pitting friend against friend whiled away many hours in amicable combat. A simple vocabulary—"your move," "crown me"—and the ability to "blow an unwilling jumper" was all one needed to know. However, let us not minimize the game smarts possessed by those early, keg-sitting Don Quixotes. Whether from experience or hand-me-down-knowledge, most old-timers knew the right sequence of moves to make. Skilled players often had to declare a draw when neither could force a victory.

Oblivious to the highly touted, weekly tournament play in England, these American sportsmen developed a quicker version of checkers known as "Give Away," the goal being to dis-

pose of all your "men" as rapidly as possible. Both games were often played with an unbiased spectator audience, but only rarely did the enterprising storekeeper engage in the time-consuming pastime.

Granted, no international champions ever came from a country store, but the potbellied-stove-sitting checker player could hold his own with the best, and he could do it while solving the world's problems, discussing the weather, and planning next year's crops.

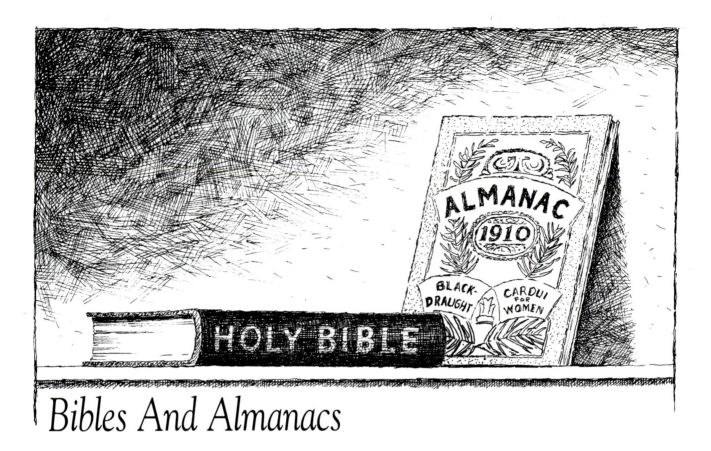

# Bibles And Almanacs

One lived by his Bible first and foremost, but very close at hand was the yearly almanac. This annual country-store giveaway publication was sought after, needed, and appreciated by everyone. At the turn of the nineteenth century all of rural America lived close to nature. The doctors, the lawyers, and the shoemakers alike grew food for themselves and their animals.

Pouring over the Bible and the almanac was a daily ritual of early Americans. Absolute trust was placed in both books. Since it provided the most accurate, scientific information one could get, planting, reaping, and butchering were all planned around the almanac's predictions.

In today's world of fingertip weather information and orbiting space satellites, it seems very odd that yesteryear's farmer relied, without question, on the words of a once-a-year publication. The hours we spend today absorbing the trivia coming at us from all directions—sports news, TV commercials, scandalous tabloids—would absolutely astound the time-conscious farmer of a century ago.

The timing of sunrises, sunsets, and moon risings have very little meaning to most people in today's fast-paced world. At one time, however, a lot of farming was done at night, so it needed to be planned for maximum moonlight. Trips to

town over soft dirt roads were scheduled with the aid of the almanac because bad weather made the roads impassable. Stopped clocks could be reset by checking sunrise times.

Annual almanacs have appeared in one form or another since the beginning of astronomy. Centuries ago, the seasonal nature of weather in Arabia prompted long-term weather predictions based on star positions. Using the position of the moon and the constellations as a record of specific past weather conditions, and compiling this information over the years, allowed for weather forecasting based on recurring astronomical circumstances.

The word *almanac* is of medieval, Arabic origin and literally meant "the place where camels kneel." *Almanac* later came to mean "campsite or settlement," and finally, in modern Arabic, it now denotes the weather at a specific site.

Harvard College supervised the printing of the first American almanacs and issued *An Almanac for the Year of Our Lord 1639*, calculated for New England. American myth has it that Benjamin Franklin founded the *U.S. Almanac* in Philadelphia, but it was in fact Franklin's brother, James, who printed *The Rhode Island Almanac* in 1728. Benjamin did, under the *nom de plume* of Richard Saunders, compile the now-famous *Poor Richard's Almanac*.

There have been hundreds of American almanacs, and the earlier ones fulfilled the role magazines later came to play in getting information to the people. The American versions contained astrological charts and weather advice just as the ancient ones had, but they also included other interesting and useful information.

*Poor Richard's*, printed from 1728 through 1753, epitomizes the importance the writers placed on correcting laziness, waste, and sin: "A penny saved is a penny earned." "God helps those who help themselves." "Early to bed, early to rise makes a man healthy, wealthy, and wise."

All the almanacs contained religious messages from the Good Book. Believers sometimes argued the meanings among themselves, but never did they question the Word of God. Never. It was not uncommon in those days for daily conversation to include Biblical axioms as the guiding counsel for particular problems: "Turn the other cheek." "Do unto others as you would have them do unto you." And, a favorite of borderline believers, "Don't mention the speck in my eye when there's a log in yours." Companions? The almanac and the Bible? Not really.

First, one read his Bible. As one writer put it, "The almanac writer writes the almanacs, God wrote the Bible, and God makes the weather."

"*I* *have painted a particular patch of wildflowers in the spring and sketched the same dead remnants in the winter. When I went back the next year the flowers were again there. My observations of the fantastic wonders of nature are enough for me to know Someone has planned everything.*"

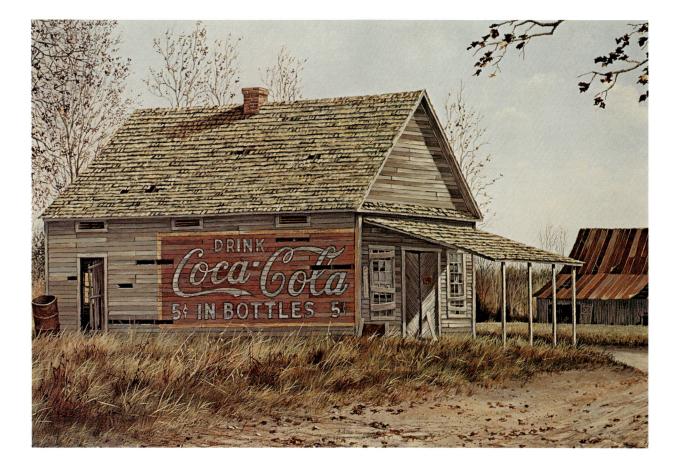

# Rain Today

A hundred years ago, all farmers in rural America had to be weather wise. Daily tasks were dictated by atmospheric conditions, and survival depended largely on one's awareness of and ability to reliably interpret weather signs.

Making crops was every farmer's goal, and there was strong camaraderie among yesteryear's agriculturists. Predicting the weather was a subject of mutual concern around the country store, but for the most part the conversations were routine and repetitive. If it wasn't raining, the talk centered on whether or not it would. If it was raining, the concern was when it would stop.

"Beautiful day, ain't it? Do you think we'll get

rain today? How much rain did you get yesterday out at your place?" During high summertime temperatures, the topic everyone had an interest in was the thermometer reading "in the shade." Even today's most common greetings include a nod of the head and a cheerful "Nice day" or "Good morning." It has been said that most conversations in America start by making some reference to the weather.

Weather lore is not susceptible to rigid definition. It seems to be a catchall phrase used to explain some of the traditional, handed-down beliefs peculiar to a particular area and people.

The basics for weather lore come from common sense, superstitions, observations, and, sometimes, wishful thinking. By no means is it always reliable, but neither should it be utterly dismissed for lack of scientifically sound methods. The best prognosticating sources are the appearances of the sky, wind directions, and clouds.

Jesus said, "When it is evening you say, it will be fair weather, for the sky is red, and in the

*"Nobody likes criticism. When someone criticizes my work, even if I ask them, I defend, argue, and finally prove that I am right. Then, when all is quiet again, I evaluate the suggestion and usually make the change. It is important to have honest, constructive criticism, and, even though I don't like it, I need to hear what's wrong. It's the only way to improve."*

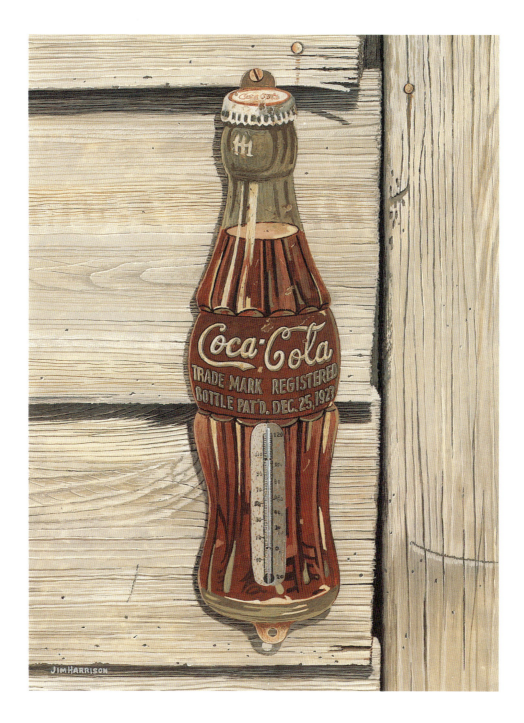

61

morning, it will be stormy today, for the sky is red and has a gloomy and threatening look." The old-timer will say, "Red sky in the morning, a sailor's sure warning; red sky at night, a sailor's delight." Since Biblical times the sky's colors at morning and evening have been used as signs to forecast weather, and rightly so.

A red or golden sky at night occurs when the dust particles in the air are dry and the temperature has not fallen below the point at which moisture condenses and forms rain. Beginning in the west and moving toward the observer, this dry air should be bringing good weather. If, in the morning, dry weather is to the east, wet weather or a storm may be approaching from the west.

In the temperate zones, where the prevailing wind is from the west, nearly all showers move from west to east. South winds bring warmth, north winds cold, and the east wind signals the approach of storms. "A cow with its tail to the west / makes weather the best; / a cow with it's tail to the east / makes weather the least." In order to detect an invader from its backside, an animal will graze with its tail to the wind. Francis Bacon noted the meteorological importance of wind when he said, "Every wind has its weather."

Cloud positions present a   visual opportunity

for predicting rain. High-level clouds indicate fair weather, while lowering clouds always mean an increase in humidity, a near-certain sign of rain. Folk wisdom tells us that "If a cloud is low and thick enough to cast a shadow it will rain."

Many old sayings attest to the influence the moon has on the earth's weather, but there is little evidence to support most of them. On the other hand, gravitational attraction does dictate the ocean's tides, and the appearance of the moon is determined by the condition of the earth's atmosphere, so there is some relationship between the earth's weather and how the moon looks. "Clear moon, frost soon" and "Moonlit nights have the heaviest frost" are two ways of saying that the clearest nights occur when the earth has been cooled by radiation, and so the air is most likely to condense moisture in the form of dew or frost.

There is an interesting body of weather lore that advances the idea that nature is more intelligent than man. It is true that plant and animal behavior does sometimes seem to predict certain weather conditions: "The wider the stripes on a caterpillar's back, the colder the winter." "The thicker the onion skin, the colder the winter." "A row of dark spots on a goose bone means a harsh winter." Except, of course, for the goose.

Slaves from Africa and immigrants from

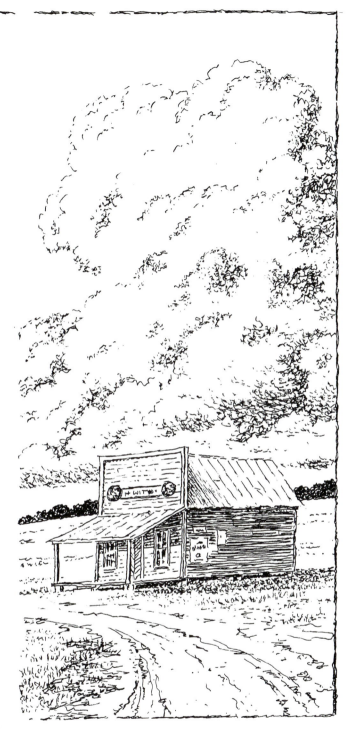

Europe brought over some of these sayings while others originated with the American Indians. They have been handed down by word of mouth from generation to generation, and it is not always possible to determine the origin or discover the scientific basis for some of the assumptions. There is no logical reason why "Pointing to the rainbow is bad luck," nor can it be proved that "To bury a snake good weather will make." Certainly, no evidence is available to substantiate the notion that the devil is beating his wife when the sun shines during a rain shower.

Many people in the Ozark Mountains profess that "Bugs march straight when the rain is near," and there is a New England saying, "Flies scatter in good weather." The Southerner claims, "A straight line of ants bring on rain," even though he would have trouble explaining why scientifically.

One can, however, count the chirps of the black field cricket for fourteen seconds, add forty, and get the exact temperature of the air. Leaves do grow in a pattern according to the direction of the prevailing winds. Therefore, a nonprevailing or stormy wind turns the leaves over, prompting the expression, "When the leaves show their backs, rain is on the way." It

LIGHTNING RODS

might be noticed that flies and insects are more bothersome just before rain. The higher humidity makes flying more difficult, and the insects are attracted to human bodies because they release more odors during a period of lowering atmospheric pressure.

A rural American of a century ago could look around him, scan the sky, breathe some good fresh air, and make a weather prediction to which no modern weatherman would dare commit.

It has been said, "Some are weatherwise and others are otherwise. Know the signs of the sky, and you will be happier for it."

*"Nature and passing time have a way of taking the ugliness created by man and making it beautiful again."*

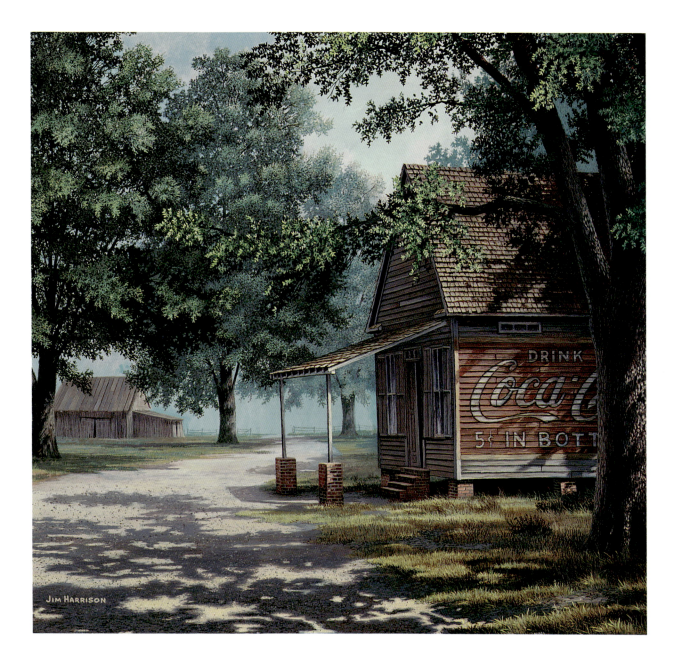

67

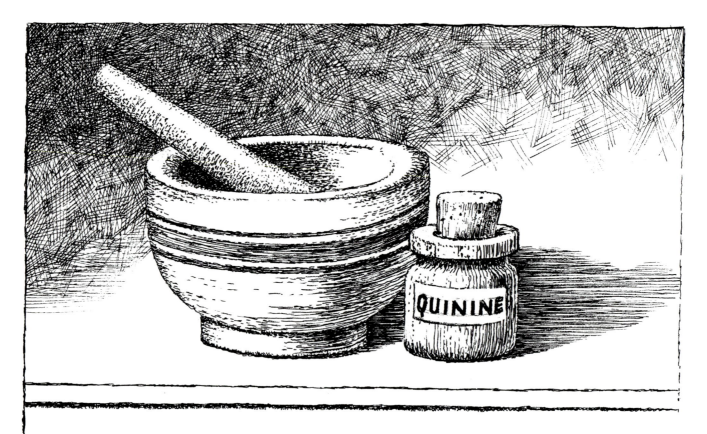

# Feed A Cold, Starve A Fever

"An apple a day keeps the doctor away." So would a pint of molasses or three teaspoonsful of brown sugar, but then, there were not many qualified doctors to keep away.

Mid-nineteenth-century medical men often lacked adequate knowledge and training. Brief apprenticeships with pharmacists or established physicians were often the basis for titles and shingles. The rural doctor of that time provided treatment within the context of his ability and the needs of his people. He prescribed not only well-known home remedies, but also compounds that he mixed. His was an age when boiled pokeberry root cured athlete's foot. Spider webs or chimney soot served as the coagulant to stop external bleeding. Fatback was unequalled as an application to draw out soreness, and a copper penny placed behind the piece of pork strengthened the medicine.

No doctor worthy of his profession entirely dismissed the possibilities of mind over matter, and consequently a variety of dishonest faith

healers and medicine shows flourished. The aches, pains, and illnesses of nineteenth-century man opened the door for exploitation by deceitful charlatans and quacks. The unscrupulous traveling medicine shows and the self-appointed public faith healers with their magical mysteries, entertaining routines, and charismatic salesmanship easily took advantage of the vulnerable population. Anyone who had an eye for enterprise and a basic formula could instantly be in the medicine-making business.

Commercial drug mixtures were often first introduced by the traveling medicine shows, but soon the crossroad country stores became the most profitable outlets for the tonics, pills, ointments, and liniments that came from big-city "laboratories." Advertising campaigns became prevalent, and people were swayed by any and all claims of super, magical cures. Trees, barns, and store sides, the billboards of that time, were lined with garish ads that offered peace and health to all who were in pain. It mattered neither where nor what the pain was. Pictured in the ads were bearded doctors or Indian chiefs who proclaimed such cures as Dr. Fahrney's Chill Cure, Indian Joe's Magic Oil, or Kickapoo Buffalo Salve. Testimonials by people with real names and faces were gathered by the medicine manufacturers, and hometown papers contained ads with endorsements by local bigwigs. Since newspaper owners enjoyed large advertising revenues from the drug companies, there was little effort by "journalists" to investigate and evaluate such products.

With temperance becoming a potent religious issue, drugs that contained a high volume of alcohol were enormously popular. The churchgoing teetotaler would not dare touch a drop of liquor or whiskey, but enjoyed the intoxicating kick in the likes of Hostetter's Stomach Bitters, Bigelow's Sagna Syrup, Ka-Ton-Ka Cough Medicine, and Woman's Friend.

In the early part of the twentieth century, the *Ladies' Home Journal* and *Collier's* waged nationwide campaigns against proprietary medicines, and president Theodore Roosevelt's personal determination resulted in congressional action. With the passage of the Pure Food and Drugs Act of 1906, an "honest statement of content" was required on labels, and many of the unethical medicine-makers were forced out of business.

Remaining on the market to this day, however, are some of the *bona fide* mixtures that came out of that often disreputable industry. Father John's Cough Syrup, Sloan's Chill Tonic, Black Draught, 666 Cold Tablets, and Lydia Pinkham, for example, have weathered both the test of time and the watchful eye of the federal regula-

*"I am an incurable collector of old signs. I have hundreds of them temporarily stored and displayed in the building next to my gallery. Almost daily someone wants to buy one, but they are not for sale. Collecting, like painting and writing, cannot be approached as a business. When I'm told of an old sign in this area there is a consuming desire to get it. I must and usually do make it mine. A person who collects with profit in mind will never experience that kind of excitement and joy."*

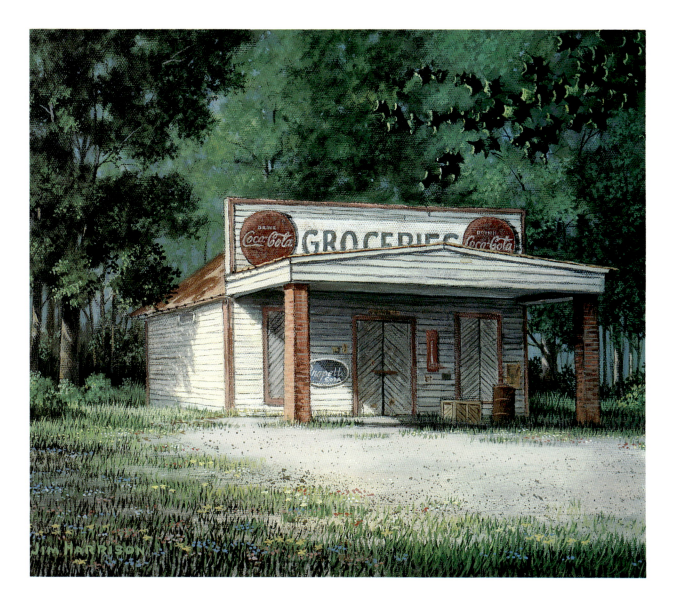

71

tory agencies. Today these products stand as over-the-counter companions to the high-powered antibiotics and the narcotic-ladened remedies of sophisticated, twentieth-century medicine.

Ignorance and fear fueled many medical superstitions in the late 1800s. Illnesses were often believed to be of supernatural origin and thus had to be treated by rituals or magic. Shoes turned upside-down under one's bed at night would relieve rheumatism, provided the sufferer spoke to no one and did not comb his hair for three days. Infant chicken pox could be cured by having a hen fly over the afflicted child in front of the hen house before sun up.

Doctors themselves had no understanding of many illnesses and could not adequately treat patients suffering from unfamiliar ailments. Emotional disorders, resulting in symptoms such as depressed catatonic moods and periods of hallucination, were believed to be of the devil's making. Faith healers dispensed special potions and conducted rituals that usually called upon the Almighty in an attempt to break mysterious spells.

The sincere, low-key faith healers, and there were some, exuded confidence in their God-given talents and professed that their healing abilities came from Him. Medical records are filled with examples of miraculous recoveries that can be credited only to the "faith" instilled by those "healers." The honest practitioners, working for no pay in a quiet and unassuming manner, simply assisted their neighbors in time of need as an act of friendship and help. Seventh sons of seventh sons and husbands and wives born with the same surname were among those supposed to have the strongest healing abilities.

Healers working with burn victims believed that the flames continued to destroy the flesh until either blown out, drawn out, or talked out. Others specialized in stopping bleeding of unnatural causes, reducing internal swelling, relieving migraine headaches, and removing frog-induced warts.

"How many dirty dish rags did I bury trying to get rid of warts on my hand? Potato juice, onion juice, and lemon juice, you name it, I tried it," lamented a twentieth-century borderline believer. "But then one day a real nice old lady said, 'Honey, you are too pretty to have those warts.' She softly held and stroked my hand, mumbled something to somebody, and the next day, I'm here to tell you, the warts were gone." With good reason or not, those who believed, believed, and those who did not, did not.

In those times a toothache was no small mat-

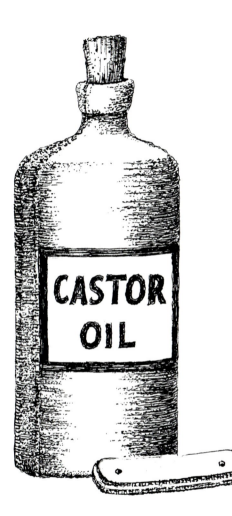

ter. This was a world without either dentists or Novocaine. Immediate relief from the constant ache was best accomplished by "getting the thing out of there." The toughest of men endured the throbbing nerve, but greatly feared the agony of a pulling pair of pliers. To reduce the anguish of extraction, the patient was told to relax for a few minutes, very still, flat on the floor. With pliers in hand, the designated tooth-puller would instruct two strong men to jerk the patient quickly to an upright position. The offending tooth would immediately be yanked out, with—it was hoped—minimal pain and before the blood rushed back to the head.

Fortunately, the root of the clove plant was found to be an effective painkilling agent. When mixed with oil and applied to an aching tooth, it provided some temporary relief. A toothache

could also be relieved by holding one's hand in a bucket of cold water and vigorously rubbing the vee-shaped area where the bones of the thumb and the forefinger meet. This method actually does work. The rubbing impulses are sent along the same nerve pathway that the tooth pain travels. Since only one signal at a time can travel a nerve, the rubbing impulse replaces the pain.

Almanacs, agricultural journals, and home-doctoring books promoted simple-remedy relief for the under-the-weather of the nineteenth century. The earliest country stores carried books on home medicine, and their shelves were filled with remedy supplies to supplement nature's agents. Kerosene, turpentine, castor oil, baking soda, and catgut were store-bought items that supplemented the natural herb roots, leaves, and animal fats that comprised the basics in any home medicine cabinet.

Sarsaparilla, sassafras, rabbit tobacco, and various tree barks had considerable value as curative agents, and many a mother brewed healing herbal tea for ailing youngsters.

Early professional doctoring was a labor of love. Even the college degree-toting M.D. at the turn of the twentieth century made fifty-cent, horse-and-buggy, house calls. Practicality, comfort, faith, and love were his main commodities. Gratitude, trust, and meager pay were his rewards.

Today's technology and modern medical men often fail to consider the necessary comfort and faith to the patient. The word *disease* precisely describes the patient's lack of ease with himself. A half-dozen decades or so ago, the task of healing was easier because the sick had faith in the treatment. Many sound folk remedies worked because people believed they would. Placebos of yesteryear are scientific fact of today.

Tremendous improvements, unfortunately, have made modern medicine impersonal, and people remember with some wistfulness the old country cures of their parents. Those cures that were based on superstitions and ignorance left a lot to be desired, but other practical remedies remain as effective today as modern wonder-drugs and antibiotics.

Many household remedies and treatments have been handed down for decades. No Latin prescription makes more sense than the centuries-old proverb "feed a cold, starve a fever," and a few drops of kerosene taken with sugar cannot be topped as a sore throat treatment. Common home remedies exist side by side today with professional, high-tech treatments, and natural folk cures that have worked over the years must be given medical credibility.

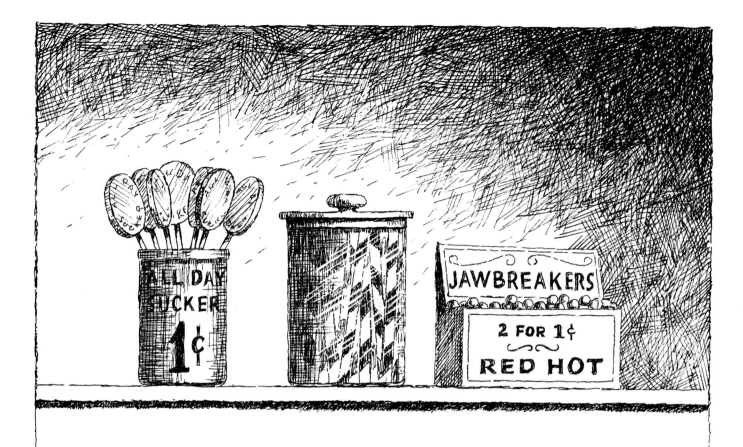

# Penny Candy

Who cannot remember tiny, hot, sticky hands reaching for a piece of penny candy? Such experiences become "eternal keepsakes of the mind," and the sweet memories are enjoyed a lifetime. The first business transactions of many youngsters were made with their little noses pressed against a glass candy-case in a crossroad country store.

Next to the counter area where goods were wrapped and bills totalled, the wise storekeeper kept jars and boxes of colorful sweet wares— always displayed at child's eye level.

Eager to stuff any and all kinds of candy in their mouths, kids very quickly recognized the truth of "get the most for your penny." All too often their selection would be based totally on quantity. Not the most colorful item in the case, but certainly offering quite a bit for the penny, a

*"I enjoy the study of words. It amazes me how the meanings change through the years. I have a few rather old dictionaries and often compare earlier definitions with those of today. Two hundred years ago the word wallet meant a handbag for carrying bits of food and other necessities for a journey. The twentieth century wallet is a mere folded piece of leather for carrying credit cards and money."*

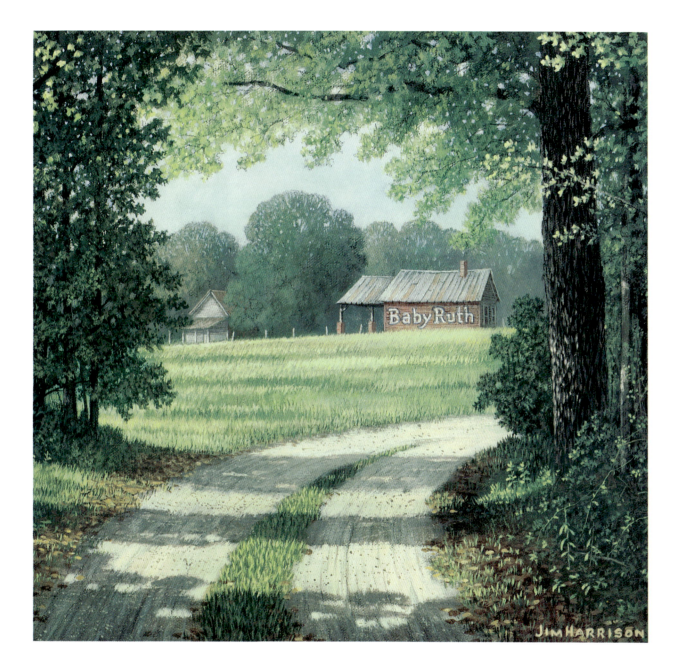

77

package of Kits included four individually wrapped squares of long-lasting satisfaction: banana, strawberry, chocolate, and vanilla.

Shining Hershey's Kisses and three-for-a-penny green mint leaves presented additional opportunities for quantity-oriented purchasers. The varieties available seemed endless, and the selection process almost enchanted the young would-be buyer. Making up one's mind just might have required viewing the glass counter several times from end to end to make certain nothing had been overlooked. An unhurried anticipation of the pleasures of the purchase was an added benefit of the one-cent transaction.

The fascination of watching the storekeeper measure a wooden beanpot of Boston Baked Beans, or the dual satisfaction offered by chewable wax bottles filled with brightly colored sweet liquid, just might be the enticement that got one's penny.

Imaginative candy producers constantly presented new items, including imitation ice cream cones and orange sugar peanuts, to compete with the old standbys like Squirrel Nuts, Mary Janes, Tootsie Rolls, and jawbreakers.

Candy, as we know it today, evolved from the medical profession of the Middle Ages when the awful taste of medicine was disguised by "sugar-coating" the pills. It was the rulers of old who first called upon apothecaries to make "sweet pills" without medicine in the middle. Because the "pills" were served only as treats at royal occasions, it was not until the nineteenth century that European confectioners realized their saleability. Very quickly the "candy profession" was taken from the doctors and druggists.

The new product was rather slow in finding its way from Europe to America, and a nineteenth-century dictionary defines candy as a verb meaning "to boil fruits in syrup and conserve them." Scarcely available before the Civil War, by 1900 candy was stock in trade for every store.

The new product was immediately embraced by the customers. There was a time when the only way for a young man to say "I love you" was with a bag of candy from the store. Young women devoured it with pleasure, and with no concern for its effect on the waistline. A standard carry-along on Wednesday and Saturday "courting" nights, store-bought candy set many a mood for romance in rural America.

"Yes siree, I sure do remember penny candy," an old friend of mine said. "Goodness gracious, did we look forward to that. You could get five Silver Bells for a penny, and there would be a lot of different colored things you could get if'n you had a penny. But now that ain't necessarily the true story either 'cause I went in the store

on some occasions and didn't have no penny but left there with candy. I didn't steal it neither. It would be a give to me by the store owner. He'd see me looking at all the candy, and I guess he knew I didn't have no money, so he'd say he got some extra so I could have a piece."

Many old-time storekeepers prided themselves on the amount of penny candy they gave away to the children. Some had a policy of giving candy to all children visiting the store with their parents, and others offered free candy with a certain amount of money spent; but more than likely, any pleading look from a child's small eyes would result in, "Pick you out a piece of candy today."

Though not to everyone's liking, one of the most popular candies was the peppermint stick. A big part of the attraction was that the red-and-white stick could be snapped into many long-lasting smaller pieces. They provided hours of staying power for hot, playing youngsters, and many a late-summer southern gnat satisfied its "sweet tooth" with the sugar overflowing from the corners of those cavity-prone, baby-teeth-filled mouths.

My old friend mentioned another all-time favorite, the all-day sucker: "Nothing would beat an all-day sucker. Now, the way I would do it, Mister, would make it an all-week sucker 'cause I'd make it last a week. No Siree, I didn't eat or suck it all in one day. I'd wallow it 'round in my mouth for a few minutes and get a good taste, but then I'd snatch it out of there to save it. Now mind you, I'd have to hide it from my brothers cause they'd be done eat theirs up the first day. No Sir, I wouldn't wear mine down. I'd make it last a long time."

And the memories, oh, they last a lifetime. The more they are wallowed around, the sweeter they get.

# Ice-Cold Coca-Cola

For almost a century "ice-cold Coca-Cola" has been hawked around the world at sporting events, movie houses, political rallies, and any conceivable public gathering. Born in a boiling black pot in the back yard of a two-story, red-brick building in Atlanta, Georgia, the universal thirst-quencher has become the world's best-known American product. It is claimed that the Coca-Cola trademark can been seen in any direction from any city street corner in the world. In its quest to be the most recognizable trademark and taste, Coca-Cola, through its

advertising, has poured, refreshed, invigorated, and enjoyed its way into the hearts of hot, thirsty, tired people all over the world.

No discussion of American business history can overlook the success of the Coca-Cola Company, the ultimate example of the American dream. No other corporation or product can match it.

The 1880s in America was an age of folk cures and over-the-counter remedies. With few doctors, and medicine still rather primitive, it was not easy to deal with pain. This was a world

of headaches without aspirin. Prescriptions ranged from "soak your feet in hot water for fifteen minutes" to "drink two teaspoons of finely powdered charcoal dissolved in water." For relief from rheumatism, bruises, and neuralgia the wealthy class routinely visited resort spas for dips in nature's own bubbly, healing, mineral spring water. Recognizing a need and seizing an opportunity for commerce, urban soda-fountain owners bottled the spring water, brought it to town, and made it available, in various forms, to pain-suffering city dwellers.

Such was the environment in which the inventor of Coca-Cola, John Pemberton, worked. Under the name of The Pemberton Chemical Company, the wholesale druggist and pharmaceutical chemist searched for new formulas and pain relievers.

On Saturday, May 8, 1886, a jug of Pemberton's newly concocted, reddish-brown syrup was mixed with plain tap water and served to the patrons of Jacob's Pharmacy in Atlanta. Described as a headache cure and fatigue reliever with a pleasing taste, it was immediately embraced and accepted as such. Either by chance or by choice, the coca-plant and cola-nut derivative was later mixed with carbonated water—as it has been to this day.

Within weeks after its introduction, all of Atlanta's soda fountains were featuring and selling the new, invigorating drink for five cents a glass. The Pemberton Chemical Company, at its own expense, decorated soda-fountain storefronts with oilcloth banners, placed signs in street cars, and ran newspaper ads promoting Atlanta's newest taste sensation.

The popularity of Coca-Cola spread, and soon Pemberton was marketing his secret formula syrup to soda fountains all over the Southeast. For shipping, he purchased used whiskey barrels and painted them red, with the words *Coca-Cola* in white Spencerian script on the side. The design became the company's symbol.

This was a time when only the wealthy enjoyed themselves. The poverty-stricken middle and lower classes worked and lived out their meager existences with the notion that hard work and suffering would be rewarded in the hereafter. Social events designed to allow for a rest from the drudgery of work did not exist, and to make time for leisure enjoyment was not part of the thinking of America's working class.

An enterprising confectioner and soda-fountain owner in Vicksburg, Mississippi, had both an eye for business and an insight into the needs of people. He reasoned that hardworking people, too, would participate in the leisurely social cus-

*"Even an old barrel or rusted oil drum becomes an object of beauty when struck by sunlight. The arrangement of light and shadow enhances the most insignificant of things. A diamond without light appears to be just another rock."*

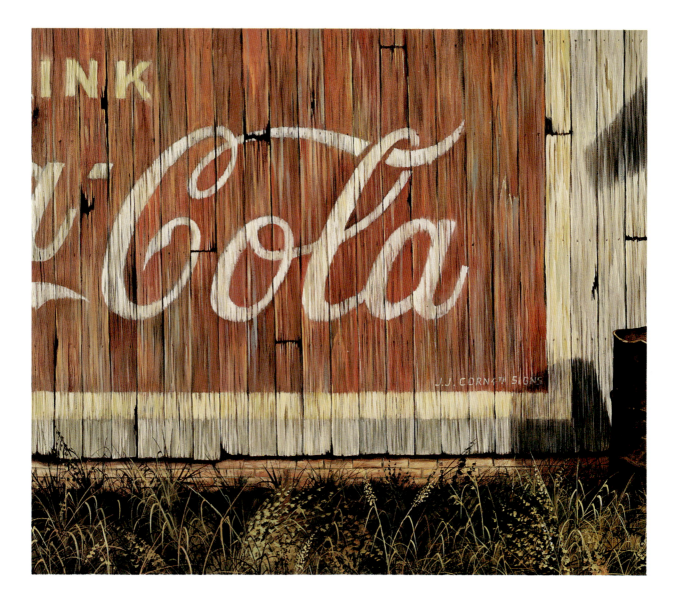

tom of drinking Coca-Cola if it were available to them. His Biedenharn Candy Company became the first bottler of Coca-Cola. By horse-drawn wagons the glass-bottled beverage was delivered to stores throughout urban and rural Mississippi. News rapidly spread of this successful venture, and by 1909 there were 379 Coca-Cola bottling plants in the United States. The returnable bottles were embossed on the bottom with the hometown and state of the initial bottler, a practice that was followed well into the twentieth century.

Soon it was discovered that the new bottled drinks sold even more successfully when served cold, which made evident the need for some type of ice cooler. The first cold Coca-Colas were stored in ice boxes along with meat, milk, butter, and cheese. Some vendors made their own crude coolers from either wooden boxes or half barrels which could be loaded with chipped ice and drinks. These early "drink boxes," later replaced by standardized Coca-Cola Company coolers, became one of the most popular gathering spots in every country store.

Coca-Cola quickly crossed all social, racial, and economic lines. It was the same to everyone. A Coke was a Coke, and the cold, refreshing enjoyment could be purchased by anyone with a nickel. According to a 1920 survey, Coca-Cola sales accounted for more transactions at country stores than any other single item. It had become a permanent part of the American scene.

A storekeeper's daughter remembers her father's liking for Coca-Cola: "My daddy loved the little Co-Colas, and very rarely was he without one in his hand or sitting around him. In fact, he often had two or three opened at once. I'm sure he drank as many as anybody. In one way or another, it seems he encouraged every customer visiting his store to drink with him. He loved to match for them and often challenged even strangers to engage. Groups of three or four would 'play for the distance,' and the participant with the drink bottled closest to home had to pay for the group. Co-Cola was a big part of his day."

The success of Coca-Cola prompted many competitors to vie for a part of the soft drink market. The early years included a number of imitators who took advantage of Coca-Cola's advertising. Trademarks were developed with the same Coca-Cola look and ring to them. One by one, Koca-Cola, Caro-Cola, Cold-Cola, Candy-Cola, Fig-Cola, Coke-Ola, Sola-Cola, and Gay-Ola fell by the wayside as Coca-Cola's legal department moved through the courts to protect its name. In 1916 the company successfully fought 153 trademark infringement cases.

Not all competitors, however, were imitators. Coca-Cola's forerunner by a year, Dr. Pepper, was developed in Waco, Texas. In the early 1880s a young man working in a Rural Retreat, Virginia, pharmacy concocted a mixture of fruit juices with a distinctive, likeable taste. The energetic soda jerk also had an eye for the pharmacist's daughter, but the possibility of their match did not sit well with the young lady's father. He fired the youthful suitor, forcing him to leave Rural Retreat. The aspiring druggist headed west, where he continued his experiments with new mixtures and formulas. Favorable reaction to one of his drinks prompted the owner of the Corner Drug Store in Waco to request a name for the sweet blend. The young man immortalized the father of his Virginia love by naming the drink after him. Legend has it that he then returned to Virginia and married Dr. Pepper's daughter.

Dr. Pepper remained a regional Texas drink for over forty years, until the mid-1920s when research at Columbia University found that people's energy drops off midway between meals. The report suggested that a shot of sugar be taken at 10:00 a.m., 2:00 p.m., and 4:00 p.m. by sucking on a piece of glucose. "Drink a bite to eat at 10-2-4" was immediately adopted as the slogan of Dr. Pepper. A clock with three hands pointing to ten, two, and four became the symbol of a drink that would sweep rapidly across the nation.

Southerners, more than their northern counterparts, tended to consume these cold, refreshing beverages—which may explain the growth of the soft drink industry in the South. Pepsi-Cola came out of Newbern, North Carolina, and Royal Crown Cola was invented in Columbus, Georgia. Like Coca-Cola and Dr. Pepper, they command their fair share of the soft-drink market.

The sound of today's talking vending machines has replaced the hawkers of the past. Cans, bottles, six-packs, twelve-packs, and plastic liter containers are carried into homes and their contents enjoyed all around the world. Radio jingles and prime-time television commercials battle for the attention of the snack-consuming public.

Things do change, but not the effervescent, popping sound of a bottle cap being removed. The action and noise for which the soda pop was named is as distinct now as it was when it was first heard in country stores years ago. Today it still invites the thirsty to pause, relax, and enjoy. It well may be that progress will one day take the pop out of soda pop, but don't count on it.

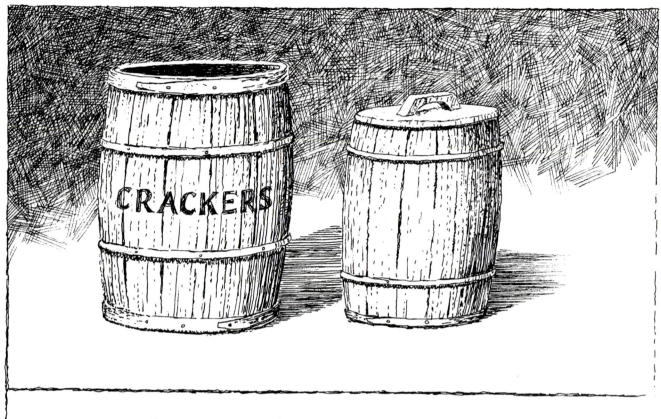

# Square Cheese Nabs

"Gimme a pack of square cheese nabs" has been a standard request at country stores for most of the 1900s. When next you pick up a cheese cracker, saltine, ginger snap, or sugar wafer, savor it for a moment, and reflect on how it became a standard snack food.

The cracker of today is the descendent of a long line of ancestors which served as food for sailors on the high seas. Seamen needed a bread food that would not spoil during long periods of time, and the cracker was the American answer.

Early crackers were an unleavened mixture of flour, water, and a little salt, kneaded by hand, rolled out, and shaped individually. For many years, this flat, hard bread was a home-industry product. During the clipper ship era, however, commercial cracker bakeries were established and flourished in New England. Those early sea biscuits, as they were called, were made by bakers who toiled long hours over hot, charcoal ovens. With long-handled peels the crackers were turned twice, a method dating back to the

making of bread for the Roman armies.

The word *biscuit* comes from Latin and means "twice baked." Probably the name *cracker* came about because of the cracking sound it makes when being chewed.

Crackers served not only sailors, but also the frontiersmen who pushed west; they were a convenient source of nourishment for men on the move in an expanding country. These baked rations, known as hardtack, became standard fare during the Civil War, but left a lot to be desired in taste, tenderness, and sanitation. There was considerable grumbling among the troops, and the many stories of weevils afloat in soldiers' cups of dunking coffee were based on fact.

As the American population increased, the baking industry expanded with it. Small local bakeries supplied the needs of their areas, but transporting their products any distance was difficult. The cracker makers got flour in wooden barrels from nearby mills and often used the same barrels to ship crackers to the stores.

The cracker barrel, a permanent fixture in the country store, became an American institution. People not only ate from it, but an endless stream of gossip passed over it. Discussions of the weather, politics, and philosophy crossed the top of its open lid. The cracker barrel more than earned its place as a symbol of basic enterprise in a young, growing, democratic nation. Truly an American idea, the country store storage barrel grew from the grassroots level.

Customers were so accustomed to the unsanitary conditions of the open barrel that they joked about it. Mice often invaded the topless container, and the store owner met complaints, usually, with good humor: "That's impossible," he would say. "Mice could not possibly live there because my cat sleeps in it every night." But humor could not disguise the fact that unsanitary eating conditions were bringing disease to millions of people and death to many. Epidemics of cholera and typhoid fever, triggered by bacteria in food and water, swept the United States in the 1870s. It was Chicago lawyer Adolphus W. Green, father of the Uneeda Biscuit, who rescued the cracker from the barrel. Through marketing and advertising, he exposed the open barrel for its unsanitary aspects and stripped it of its sentimental value. His vision and leadership led to the founding of the National Biscuit Company, the company that was to dominate the American cracker and cookie industry to this day.

Green's first product was a greatly improved, light and flaky soda cracker. He had the corners cut off to give it a unique octagonal appearance, and he insisted the name had to be equally dis-

*"I am never without a sketch pad. I constantly think with my pen in hand and either jot down thoughts or make sketches. The most basic of all the arts is a black line against a white sheet of paper. It does something for me."*

tinctive. Among the names under consideration were Taka Cracker, Hava Cracker, USA Cracker, Racha Cracker, Wanta Cracker, and the selected one, Uneeda Biscuit.

A revolutionary wax-paper-sealed packaging devised by the company was given its own name, "Inner-Seal." The new technique marked the beginning of modern merchandising in the baking industry.

The search for a catchy logo resulted in a clear-eyed, chubby-cheeked, five-year-old boy embodying all the characteristics of clean-cut children. Dressed in rain gear and holding a box of dry Uneeda Biscuits, he called attention to the moisture-proof packaging. The Uneeda Biscuit Boy, clad in his yellow rain coat, took his place on the shelves of country stores everywhere and soon became one of the world's most recognizable human trademarks.

Fancy English cakes—called cookies by Americans—were being imported into this country by the later part of the nineteenth century. Shaped in the form of various wild beasts, these popular treats took on the simple generic name of "animals." When the National Biscuit Company adopted "animals" as a part of its product line, their name was changed to Barnum's Animal Crackers after the showman and circus owner, P. T. Barnum.

Barnum's Animal Crackers were packaged in a small rectangular box resembling a circus wagon with a string at the top for easy carrying. The crackers were first introduced during the 1891 Christmas season, and some argue that the string was for easy hanging on the Christmas tree. Whatever the intent, they became a steady year-round seller and soon were a part of the American scene. Every kid knew there were seventeen types of animals: bison, camel, cougar, elephant, giraffe, hippopotamus, hyena, kangaroo, lion, monkey, rhinoceros, seal, sheep, tiger, zebra, and two versions of bear.

Advertisements using poetry with a rhyming message kept the nation's children asking for boxes of animal crackers:

"A cracker lion cannot roar, and wouldn't if he could;/but kiddies like him all the more because he tastes so good."

"Animal Crackers and cocoa to drink,/that is the finest of suppers I think;/when I am grown up and can have what I please,/I think I shall always insist upon these."

In the roaring 1920s, the National Biscuit Company introduced a five-cent, sealed package of square cheese crackers with peanut butter sandwiched between. The new package aroused considerable interest both within the company and across the country. The compa-

ny's traveling salesmen had wanted a low-priced product to serve as an entree into ice cream parlors, road stands, country stores, newsstands, and drugstores.

This new addition to the product line deserved a special name. On March 30, 1928, the company adopted the already widespread name "Nabs," a derivative from the word Nabisco, which, in turn, is short for National Biscuit Company. Nabs quickly became one of the company's best-known trademarks. Now, three quarters of a century later, the name can still be heard at some of the remote country stores: "Gimme a soda and a pack of Nabs"—a great tribute to a company that has grown up with America.

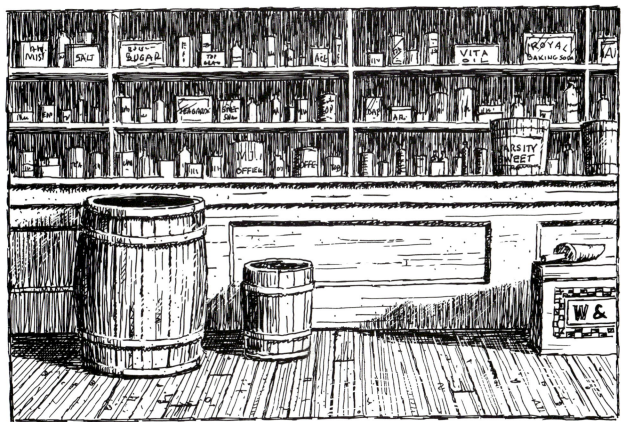

## Satisfaction Guaranteed

Not even Santa Claus himself brought as much excitement to the early-twentieth century rural household as did the summer and winter arrival of the Sears and Roebuck catalog. The colorful wishbooks were designed for hours of reading, and often they were pored over from cover to cover many times. The thick catalogs provided the isolated farm families with opportunities to buy, to review the new fashions, and to enjoy glimpses of city living that they would not otherwise see.

In the late 1890s industrialized America was expanding and making many new products available to a people eager to improve themselves.

The country store, limited by space and the lack of volume sales potential, could not afford to stock the constant avalanche of new items.

Catalogs from mail-order houses were made available to customers as counter displays, and orders were placed through the storekeeper. Credit, or installment buying, was not offered the public until after the turn of the century, so cash had to accompany each order. And cash was something the rural customer seldom had in those days. For an interest fee, the storekeeper advanced the needed money, sold the money order, and collected profitable freight-handling charges. Mail order did add cash to the store's coffers, but much to his later detriment, the local merchant played a major role in the expansion of the mail-order business.

The local store had served the farmers well for years, but the choice of goods was limited and the prices were inflated because of the numerous middlemen. By the last decade of the nineteenth century, the rural merchants were in a very vulnerable position.

The beginning of the demise of the crossroad country store can be marked by that date in 1896 when Congress enacted Rural Free Delivery, and outlying families began having their mail delivered to their homes. The mailman carried with him stamps and money orders, thus eliminating the need for postal services from the store. Reorganization of the post office department created larger, centralized facilities in the towns and eventually made the country locations obsolete. The loss of the store's post office meant less store traffic and reduced the store's status as the community's social and economic center.

Bad news for the store owners proved to be good news for the young mail-order businesses and their customers. The direct mail concept had an inauspicious beginning when Ben Franklin used the mail unsuccessfully to market his Pennsylvania stoves. And at first glance, the mail-order business seemed an improbable scheme for the early twentieth century. It required hardworking people to send their hard-earned money to some faraway place to a person they did not know for a product they could not see. But Americans were hungry for the ever-growing list of new items that they could not get at the store.

Mail-order businesses were springing up all over the country, and the undisputed leader was Montgomery Ward. However, with a satisfaction-guaranteed-or-get-your-money-back policy, a young Minnesota railroad station agent launched a mail-order career that would not only challenge but surpass Montgomery Ward and go on to become an American phenomenon.

*"A person with nothing to say seems to talk the most. A painter or writer with no message runs the same risk."*

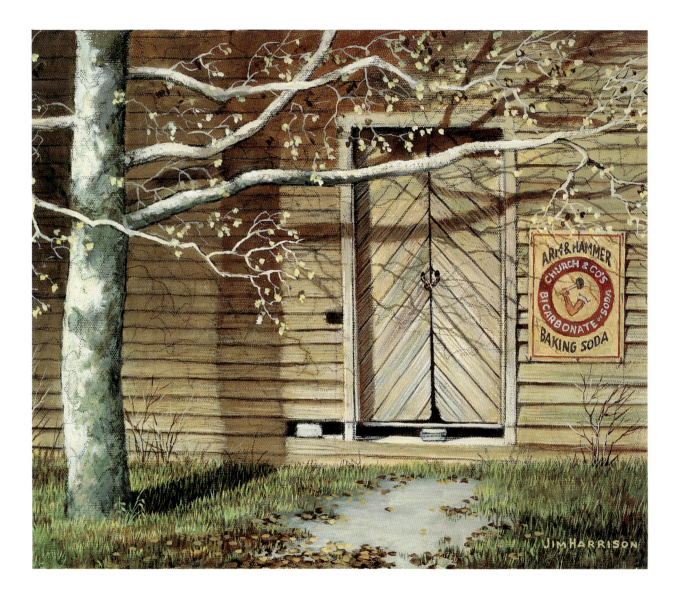

At age nineteen, Richard Sears received a shipment of unclaimed watches at his railroad freight office. With an eye to the future, he recognized the imminent need for these handy devices. The country had just been divided into time zones by the railroad companies in Chicago. Timepieces would no longer be a luxury; they would soon become a necessity. Even the smallest hamlet had to conform to Railroad Standard Time. Sears made a deal to acquire the shipment of unclaimed watches and began a selling career that would never be equalled. Within a few months his watches were selling steadily, and he quickly accumulated a small fortune of $5,000.

Later Sears hired his own watchmaker, Alva Curtis Roebuck, and these two men of extraordinary vision eventually established a new firm—Sears, Roebuck, and Company—initially organized to sell watches through the mail. The concept and potential of mail order so intrigued young Sears that he convinced his more conservative partner that they needed to expand their offerings and sell more items through enticing, semiannual catalogs. Sears thought of the catalogs as a store window going into every American home. He wrote all the copy himself, with great descriptive detail and honest guarantees. He and Roebuck revolutionized the American way of life. The two men influenced how Amer-

## MEN'S HATS

icans dressed, the decor of their homes, the tools with which they worked, and even the dreams they dared to dream.

They sold shoes, shirts, Mason jars, pocket watches, shotguns, apple peelers, corn planters, and everything from the kitchen sink to school

bells, freckle cream, pianos, and gumdrops. Every item was described as the finest grade, factory tested, delivered to your door, and guaranteed to satisfy or your money back—an unbelievable offer to product-deprived rural families.

So successful was the direct-mail campaign that it began to threaten not only the country store but the small-town retailer as well. The savvy merchants realized what was on the horizon and initiated an all-out campaign against the mail-order companies. For the purpose of destroying catalogs, storekeepers sponsored bonfires and offered very tempting premiums at their businesses to anyone who would cast his copy into the fire. Newspapers were afraid of losing local advertising, so they helped with critical publicity and editorials, often creating such jibes as "Rears and Soebuck," "Shears and Sawbuck," and "Monkey Wards." Other media helped keep alive the futile fight against the expanding companies by publishing any negative information, no matter how questionable the source. Rumors were circulated that both Sears and Roebuck were simply out to profit from the ignorance of the rural population. Accusations of cheap, poor-quality goods were reported regularly, but Sears' campaign was so effective and so timely that nothing could stop the success of his concept. His company did, in fact, do exactly what it said it would do, and it strived hard to gain and keep the faith of the American buying public.

Good products, good service, and reliable honesty did gain the confidence of the American people. In the 1920s Sears claimed to have eleven million families ordering semiannually. A national institution providing nationwide service had been born and was prospering.

Claiming the distinction of the "World's Largest Store" in 1923, Sears began operating its own radio station, WLS in Chicago. For some years the station functioned as a service for its customers, providing numerous farm reports and the entertainment of the time. At the same time, of course, Sears increased sales of radios by creating reasons to own them.

A new way of life was emerging for Americans, and the crossroad country store was losing its identity and usefulness. Mail order and mass marketing were concepts whose time had come, and they proved to be powerful forces against which the small rural merchant could not compete. He, too, had new needs, and his vision, however countrified, continued to serve him well. More than likely, his safe began to accumulate shares of common stock in Sears and Roebuck. "If you can't beat 'em, join 'em," the wise old merchant would say, and he too was guaranteed satisfaction.

98

# Sonnets and Signs

"A peach looks good with lots of fuzz / but man's no peach and never wuz" was one of over seven hundred Burma-Shave jingles installed as serial signs at some 35,000 locations throughout America. Steering a Ford V-8 at thirty miles per hour with the scent of honeysuckle and warm road tar in the air, the motorist passed a complete set of those rural ballads in just twenty sec- onds. However, the rhythm of the jingle and the anticipation of the next message held the atten- tion of drivers—especially vacationing fami- lies—for hours.

Assigned now to pleasant memory and seen today only in museums, the catchy Burma-Shave ditties provided many moments of pleasure and successfully thrust the financially plagued Burma-

"*There were no junkyards or flea markets a hundred years ago because people didn't throw things away. Leftovers became next days dinner. Soap and candles were made from next to nothing, and most of the tools were fashioned from broken-down implements. Workshops contained once used balls of string, jars of used nails, and screws that always had a later use. Frugality was an all-American trait that was admired. Today's thriftiness is often sneered at as being stingy and tight.*"

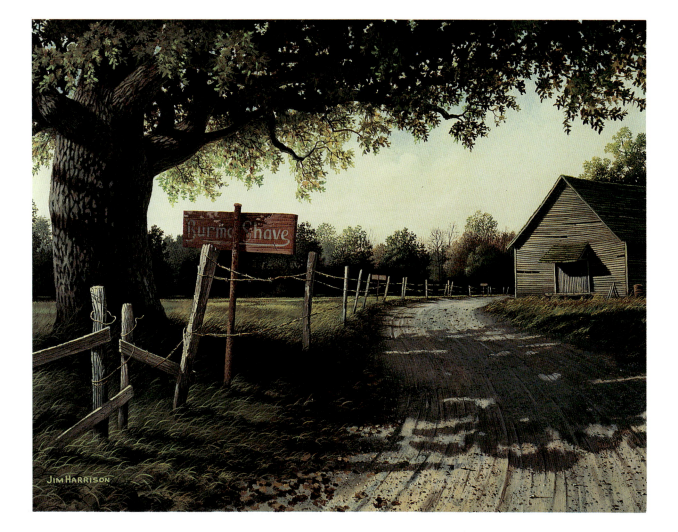

Vita Company into a profitable American wonder. More important, a nation of older people remember well the poetry of a brushless shaving cream and are both surprised and saddened that the Burma-Shave signs no longer dot the roadside. Gone the same route to obsolescence are the outdoor-wall and rooftop bulletins of Mail Pouch Tobacco, See Rock City, Bull Durham, and many other memorable advertisements.

The primary purpose of any commercial sign is to create a visual means of promoting a product in order to increase sales and expand the market. The intent is not to manufacture a future relic with collectable monetary value. However, passing time does just that to the most unlikely and insignificant things. As the years go by and the everyday environment slowly changes, there creeps in a certain romance or longing for what once was. Such is the status today of antique American outdoor advertisements.

Early-twentieth century ad men were not known for their humor, and copywriters composed long, fear-inspiring messages explaining why consumers had to select a product. Absorbine, Jr., stated that women's feet were cracking and had to be treated. Feen-a-mint sent out nationwide warnings that the entire country was suffering from irregularity. Lifebuoy and Listerine waged battles against body odor and offensive breath. But the late teens and the roaring twenties provided a fitting environment in which to try new approaches to commercial messages. The new philosophy culminated one autumn day in 1925 when Burma-Vita installed its first sets of roadside jingles on secondhand, three-foot-long boards placed one hundred paces apart. A bold advertising campaign was initiated that would never be duplicated. The repetitive, cutesy jingle cadences, coupled with folk humor, captured the attention of all America.

Only the work of the traveling evangelists and reformers who left their Biblical messages painted across the countryside— "Prepare to meet your God," "God is Love," and "Jesus Saves"— could match the enthusiasm of the Burma-Shave promoters. Rocks, barns, and rooftops were all targeted by this army of God's graphic messengers, who, like their commercial counterparts, also knew the value of consistency and repetition.

Appearing on the doors, shutters, posts, and outer walls of country stores were numerous tack-on signs. They communicated the healing benefits of Sloan's Liniment, Goody's Headache Powder, and Black Draught, while Philip Morris, Lucky Strike, and Camel cigarettes made claims of enjoyment and relaxation.

The traveling salesmen of that time carried

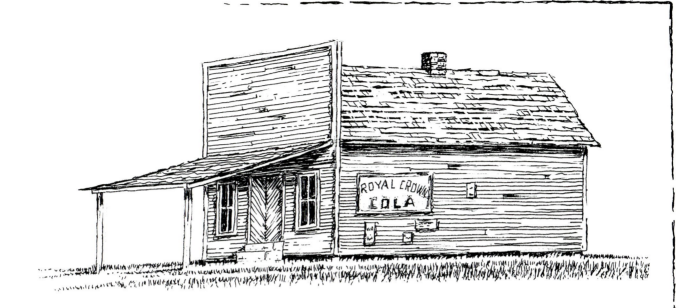

with them quantities of their products' signs, and the various vendors vied for the vacant and most visible spots on the stores. Many a tale is told of never-ending battles between salesmen who would remove their competitors' signs only to replace them with their own. Thermometers, door pushes, and a wide variety of giveaway items were thrust upon overwhelmed proprietors, who, likely as not, responded, "Put it wherever you can find a space." The evidence today is in the aged wood of the surviving country stores, peppered with hundreds of tacks and holes where once the many placards hung.

Hand-painted advertisements, long faded, seem to peer from out of nowhere on the sides of the weathered buildings. Faintly visible are the names of long-forgotten tobaccos, breads, cough syrups, and salves. And the likes of Coca-Cola, Wrigley's Spearmint Gum, and Pillsbury Flour continue to make their presence known, paled now by three quarters of a century of sun, rain, and freezing temperatures. A deliberate stare will revive the muted colors, and once again yesteryear's trademarks and slogans are discernible.

Such are the painted wall bulletins of the early years of the 1900s. In their heyday there were many. The bulletins first appeared alongside railroad tracks when trains were the main means of travel. Soon they followed the path of the automobile as it passed barns, sheds, and country stores. Any visible, flat surface was a prime location for one of the corporate messages.

The larger of the outdoor advertising agencies, located in the metropolitan areas, competed

for the accounts of major companies. The agencies' "location men" traveled the rural expanses for months at a time, securing the best sign spots and completing lease agreements with the property owners. Various arrangements were worked out, which might include painting the entire building, paying usage money, or even providing the owner with an unending supply of the product being advertised.

With the warmth of spring weather in their favor, the two-man sign crews would follow the course of the "location men." Equipped with directions, company-prepared sketches, and layouts, the painters would remain on the road five or six months at a time. Each crew was expected to complete a large wall bulletin in a day. Prepared, perforated, pounce patterns added speed to the massive task, but still, many jobs were finished after dark by the headlights of the Model T crew-truck.

The late-night travel required to get to the next location did not leave much time for rest or sleep. In addition to equipment and supplies, the truck also carried a bed for those occasions when no rooms were available. Weekends, however, were reserved for hotels. A good bath and freshly washed clothes were welcome luxuries after days on the road.

Oftentimes the sign painter bartered his lettering skill for food and lodging. Weekend moonlighting was a way of life. Many a town's water tower, hotel sign, or restaurant mural was painted by these Sunday workers.

Either justly or unjustly, the sign painters carried with them the reputation of having a propensity for drink. The public was often left with the impression of a man with a fitch brush in one hand and a fifth of whiskey in the other. There may be some truth to this, but the traveling sign men worked long, hard hours and imposed upon themselves the title of "wall dogs," perhaps because they worked like dogs. For some, the job was a stepping stone to greater things, and a few went on to become either commercial or fine artists. America's best-loved artist, Norman Rockwell, was once an itinerant bulletin painter earning $12.50 a week.

Whatever their reasons for bulletin painting, those graphic muralists certainly left their mark. Fighting against an avalanche of outdoor paper bulletins, neon, and lighted plastic signs, some wall dogs persisted in their own way all through the years. Determined but outdated, one by one they have traveled the road to extinction.

Should you happen to see someone perched upon a ladder, brush in hand, leaning against a bulletin, do stop and take a long look. You will be watching the last of a breed.

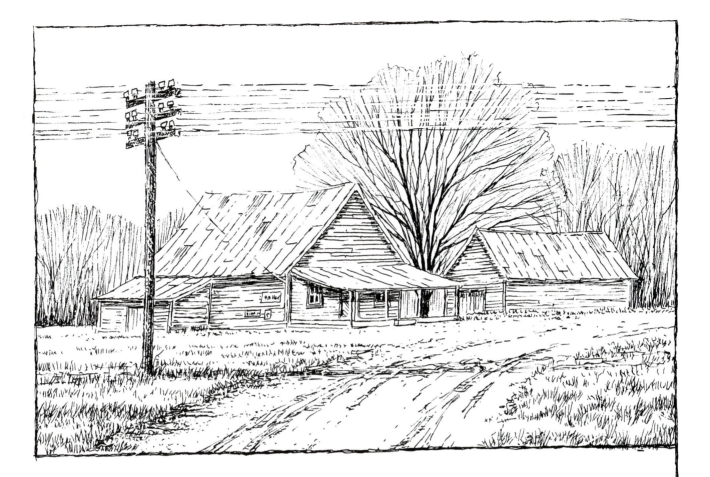

# Eavesdropping and Gossip

"Number please?" was the usual request made by the local switchboard operator. "Four-six," "nine-three," or "one-oh-one" might have been the response, whereupon the caller was manually connected with the desired number. The turn-of-the-century, crank-type wall telephone provided the American people a better means of communication than any method before it. Hundreds of

isolated—often out of order—locally owned telephone exchanges served the rural area long before there was an efficient nationwide hook-up by the Bell System.

Urban and rural store owners were the first to have telephones, and they made regular use of the newfangled talking boxes for calling in merchandise orders. Nor was it uncommon at that

"Mr. Cornforth was very superstitious about the color green, and to my knowledge he never owned a can. He believed it was bad luck. When a sign job called for green we always used yellow mixed with blue or black to make the color. I never knew why he felt that way, but to this day I mix on my palette all my greens from blues and yellows."

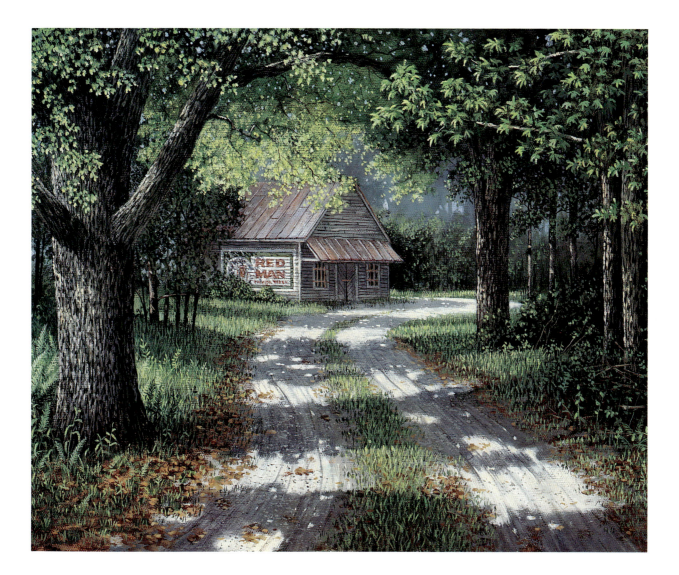

time for people in rural areas to rush to the nearest store's telephone to summon the services of a doctor or other emergency help.

For centuries men have been determined to invent faster ways of communicating. From footrunner to horseback rider and from the telegraph to the satellite, the quest has included Indian tom-toms, smoke signals, flashing lights, signal flags, carrier pigeons, and church bells.

Various kinds of mail services and the printed word of newspapers and magazines remain vital cogs in the overall communication network. But the need for faster, more dependable, and more immediate methods of exchanging information has long captured the attention of inventors and men of vision.

As with the evolution of almost every industry, some improvements change the entire world and forever stand out above the rest. Such was the result of Alexander Graham Bell's naive curiosity and inventive genius. For over a hundred years his telephone has served much of the world's communication needs with little modification in his basic concept.

A Scottish immigrant, Bell was a teacher of the deaf by day and an inventor of hearing devices by night. He realized that variations in an electrical current could be used to transmit sound over a wire with little distortion on the receiving end.

After nine years of research and experimentation, on March 10, 1879, Bell was preparing to test one of his revised transmitters when acid spilled on his trousers. He immediately yelled to his assistant, "Mr. Watson, come here, I want you!" His summons, accidentally heard through the receiver on the other end of the test wire, was the first telephone message.

More recently, an elderly farmer reminisced about his early experiences with the telephone. "Yes sir, I sure do remember the ol' crank-type phone. You'd have to ring and ring up the operator. You'd give her the number you wanted. Most everybody had a party line back then, and the people's numbers all had different rings. Might be one long ring and two short ones or two long and one short or mixed all together. Yes sir, them party lines was somethin' else! And eavesdroppin', it was alright 'cause everybody did it. But for no reason. You didn't have to. We knew everybody's business from all the talk and gossip down at the store."

Today the telephone has become such an important part of our lives that its use is more instinctive than conscious. In the history of inventions, no other device has been used with such speed and efficiency and with such little regard for the device itself.

# Wireless Newspapers

"Andy, we has got to find a way for de Kingfish to get Sapphire back. He say he can't live one mo day widout his honey." The comic lines of Amos and his sidekick Andy captivated a neophyte nationwide radio audience with their unending attempt to keep the Kingfish in the good graces of his demanding wife, Sapphire.

"The Amos and Andy Show" was probably the most famous and most popular radio comedy of all time. The serial was broadcast on weeknights from seven to seven-fifteen and was then considered prime time entertainment. So addict-ed were listeners to the show that movie houses timed their intermissions to allow the program to be heard through the theaters' sound systems. City department stores responded to their customers' requests by arranging to have the comedy played over in-house loudspeakers for the enjoyment of nighttime shoppers. Loyal rural listeners huddled around the lone, country store radio, anxiously waiting to hear if Sapphire agreed to take Kingfish back one more time.

In the early part of the twentieth century, there were many individual amateur radio

"*We try so hard to quickly duplicate the effect of age. The new modern trend in teenage clothes is to have the instant old look without the effort. New jeans are heavily laundered and stone washed by the manufacturer to give them a faded look and the soft feel of a well-worn, old favorite. New furniture is antiqued with synthetic patinas, and new houses are built with old brick. But new cannot be old and the pleasing effect of real decay takes time.*"

110

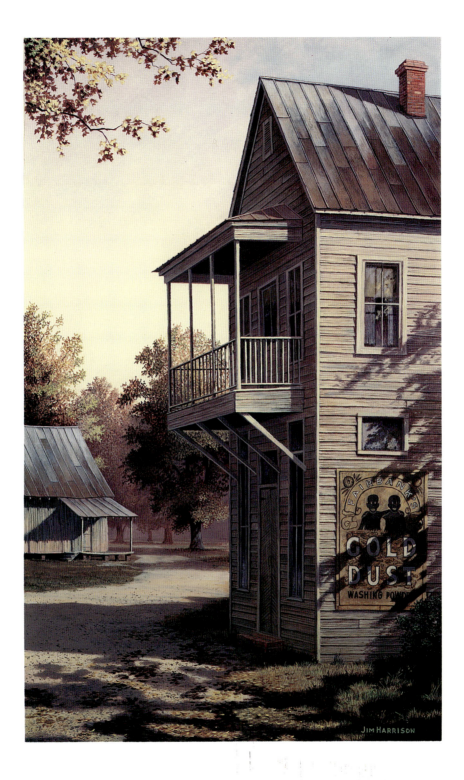

enthusiasts, and the wireless was in place as a means of ship-to-shore communication. It was the Westinghouse Company which first envisioned a greater potential for radio and introduced the concept of broadcasting as a medium for entertainment. In October of 1920 from a tower atop the Westinghouse Building in Pittsburgh, station KDKA sent out its first test signals. A few days later about one thousand people in the Pittsburgh area heard radio bulletins that Warren Harding had been elected president of the United States.

The press quickly picked up on the exciting new medium and spread the news that the era of professional broadcasting services had begun. The Westinghouse Company was swamped with requests for more information. The company quickly recognized the huge market potential for radio receivers and became the spearhead for the manufacture and sale of sets. It was evident to company officials that stations in other locations would generate orders for its radios, and by 1921 Westinghouse had established WBZ in Springfield, Massachusetts, to serve New England, WJZ in Newark, New Jersey, to serve the New York City area, and KYW in Chicago.

On July 2, 1921, some 200,000 sports fans listened to the Jack Dempsey-George Carpenter world heavyweight championship fight originating from Jersey City. The response from the public was overwhelming. By the next fall there were more than 220 stations on the air. Early on, station owners realized that their transmitters could be connected by long-distance telephone lines for the purpose of simultaneous broadcasts. This birth of network broadcasting came in time to air the 1922 World Series. The future for radio was being anticipated, but the economic possibilities of on-the-air advertising had not yet been considered. The initial commercial thrust was to create a desire for and to promote the sale of receiving sets.

Politicians seized the opportunity to make radio speeches, preachers delivered sermons via the airwaves, and agricultural experts broadcast daily market reports, and the commercial value of a voice through the air was soon to be discovered.

The new radio craze swept the entire country, and the stores in the cities could not get enough sets to meet the growing demand. Especially for country folks, the radio became a vital and tangible link to the outside world. At first, broadcasts were available to them only through the "radio down at the store," but gradually the rural population equipped themselves with their own battery-operated sets. The limited life and the cost of a battery forced selective use of the

receivers, but every night rural families gathered around the small sets, transfixed by the sounds that filled the farmhouse parlors.

Radio entered its golden age in the late twenties, and a variety of programs became available. "The Lone Ranger," "Buck Rogers," and "Gang Busters" were afternoon adventure shows designed for children. Millions of women listened to daytime dramas—called "soap operas" because the soap manufacturers sponsored and financed them. The big band music of Tommy Dorsey, Guy Lombardo, and Glenn Miller poured into living rooms and kitchens, and into urban and rural stores in every corner of the country. The humorous family squabbles of "Lum and Abner" and "Fibber McGee and Molly" were aired to an attentive and adoring audience. Like television viewers of today, radio listeners sat staring intently at their receiving sets.

Radio influenced people. It transcended distance and made neighbors of everyone. News and information were sent from coast to coast and even nation to nation. Listeners were transported from their homes to interesting places around the world.

Every Saturday night during the early thirties, barely audible above the radio static, came a faint, distant message: "Good evening, I am speaking to you from Little America, Admiral Byrd's remote Antarctica base camp at the South Pole. I hope you can hear me."

The thought of hearing a live voice from nine thousand miles away was almost unbelievable, but Americans' appetites to move about and see new things were whetted. Far off didn't seem so far off anymore. Town seemed closer, and rural people wanted to go there. The crossroad country store sat a step closer to the edge of extinction.

# Horseless Carriages

When the proud rural car owner purchased his first automobile fuel from the obliging country store owner, little did either realize the irony of the occasion. The very gasoline from the gravity-flow pump would eventually zoom the motorist past the dying country store in his search for more varied shopping opportunities in nearby towns and cities.

The erstwhile lingering visit to the crossroad store was soon to become a quick "Fill 'er up," grab a pack of cigarettes, pay, and be gone. Stores' front porch rockers were replaced with glass motor-oil containers, grease guns, and water cans. Towering hand pumps added to the equipment and to the confusion in a fast-changing rural scene.

A once laid-back shopping environment had now, itself, assisted in making convenience and time-saving an important consideration. Leisurely store visiting and casual conversation soon would become a rarity. Fast foods, the convenience store, and the gasoline service station were on the horizon, and the end of the country store was in sight.

Henry Ford is credited with having put America on wheels, but his vision was the culmination of the work of many others. The idea of motorized land transportation dates back over several centuries. Even Leonardo de Vinci considered the idea of self-propelled vehicles. In 1760 a Swiss clergyman suggested mounting small windmills on carts. The power produced by the windmill wound a clock-like spring to produce the driving power. Wind was successfully used in Holland to propel carts, and there is other early evidence of large, experimental clockworks in vehicles.

The first steam-powered automobile was made in France in 1769, but steam power reached its peak in America in 1906 when the Stanley Brothers established a speed record of 127 miles per hour in a Stanley Steamer. Battery-powered and gasoline engines took second and third place behind steam-powered automobiles at the turn of the twentieth century.

Henry Ford was a man with the mechanical skill necessary to make an automobile in his own barn, by himself, with his own hands. He also had the ability to manage mass production on a scale unparalleled in his time. Ford's idea was to turn the automobile from a luxury and a play-thing into a cheap, versatile, easy-to-maintain mode of transportation. He dreamed of "a car for the great multitude."

He started The Ford Motor Company in 1903, designed his car first, and then determined how to produce it cheaply. The so-called Model T, the best-known motor vehicle in history, was built for durability on the rough American roads of that time. It was economical to operate and easy to maintain and repair. First put on the market in 1908, it was discontinued in 1927.

Ford's philosophy was simple: reduce the price of the product, increase the volume of sales, increase output to sell at an even lower price, and then repeat the cycle indefinitely. Within two decades Ford had put America on wheels. His assembly-line method of a conveyor system with many individual repetitive tasks lowered the price of the Model T from $950.00 in 1909 to $290.00 by 1926.

The effect of Ford's affordable automobile was much greater on rural Americans than on those who lived in the cities. It brought an end to the isolation of country people.

"*Today when we speak of savings we think of money in the bank. In earlier years in this country money didn't have the same meaning. A man's security was measured by the amount of wood he had for the winter and the hams in his smoke house. What little money he did have was kept in a cookie jar or sugar bowl and not even considered necessary for living.*"

116

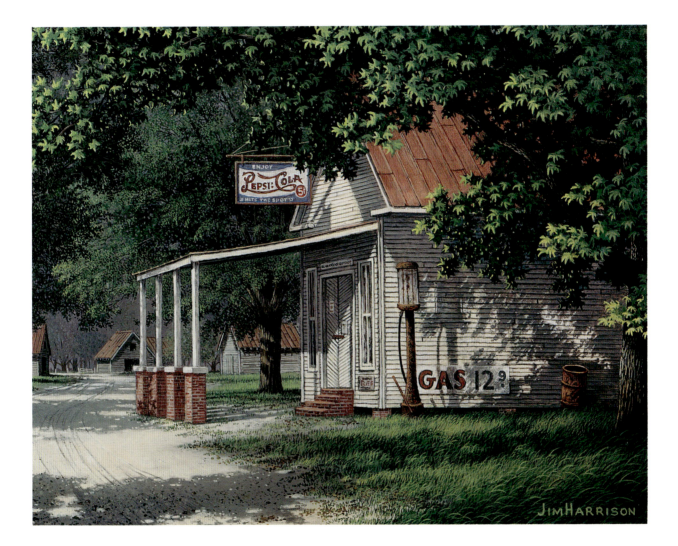

# Sorry, We're Closed

And so it has come to this. The heavy doors, which opened to the only contact most customers had ever had with the rest of the world, were closed, never to open again. By the mid-thirties, the country store had slipped into the past. Automobiles and improved roads had shortened the country mile. Fifteen million Model T's were on the road, and the Model A had been introduced in 1927. Fourteen other car makers were supplying automobiles for the one out of five families who owned them. Telephones connected rural homes to cities, and

radios brought the world to the country. Most of America was electrified and citified.

Chain food stores, with lower prices and wider selections, were firmly entrenched in most small towns. Woolworth's Five and Ten stores numbered in the thousands and took over the market for gadgets and incidentals. The mail-order houses were flourishing, and national advertising made the housewife brand conscious. The crossroad store was forced to settle down and retire.

It's not very likely that you will seek out and find one, but if by chance you happen upon one of these relics, be aware of where you are. A step through the old door will take you back three quarters of a century, and inside, time will have stood still.

As you listen, you will hear the history of commerce in the making—the "pop" of a soft drink being opened, the "cracking" of chewed soda crackers, or the "ring" of a small brass cash register.

Throughout its history the country store was on the cutting edge of progress. From cracker barrels to Oreos, from penny candies to Whitman's chocolates, right there it's been. From candles to light bulbs, and from flour bins to loaf breads, it was there. Much to its own detriment, each advancement carried the customers further and further away from the store's front porch steps. Nevertheless, it always did its job well.

Standing in the doorway, you will be caught with one foot in the past and one pointing to the future. Memory will serve you well at the moment, but time must move on and in its ruthless way leave behind much that was good.

Never again will the wood stove seem so warm. Never again will the porch seem so shady. And never ever again will the candy taste so sweet.

*"I'd like to be remembered as a writer, painter, and thinker. If only one, I'd choose to be a thinker."*

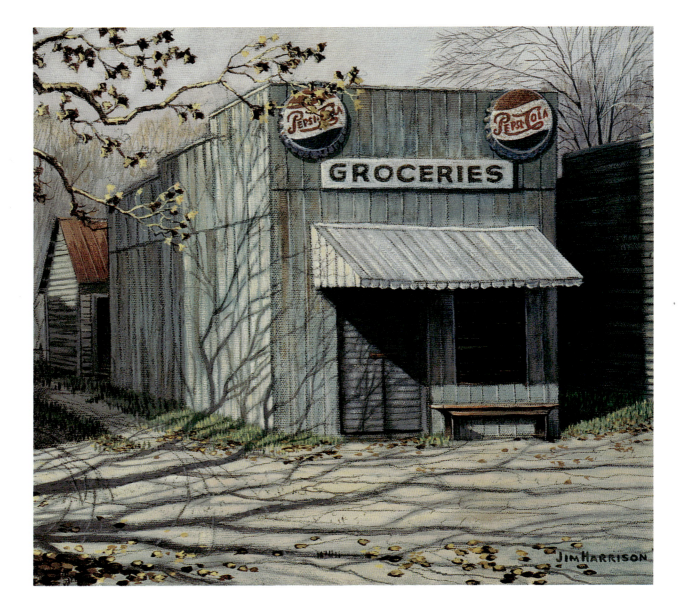